GAUGUIN

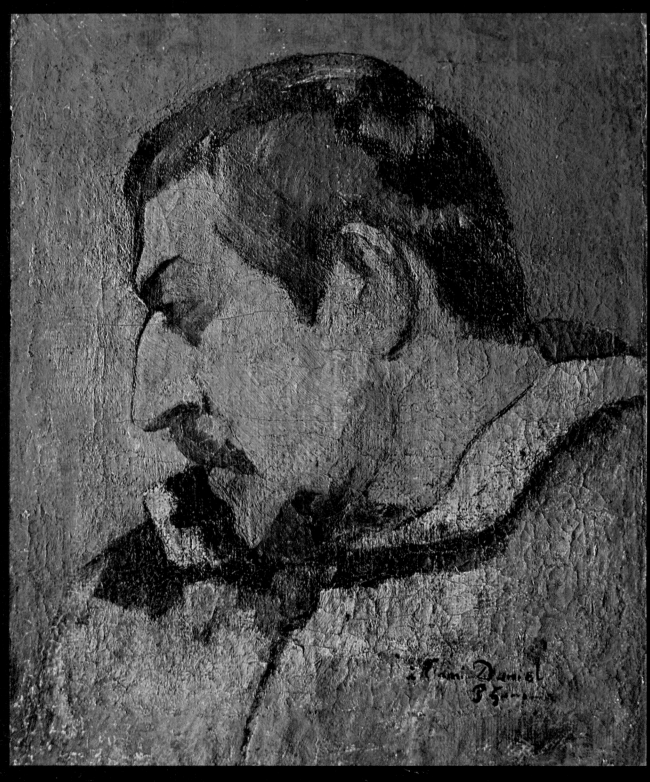

Self-Portrait Dedicated to Daniel de Monfreid, 1897.
Canvas, 15¹/₄ × 13³/₄ in. · Paris, Musée du Louvre, Jeu de Paume.

GAUGUIN

DANIEL WILDENSTEIN - RAYMOND COGNIAT

THAMES AND HUDSON · LONDON

CONTENTS

Photo credits: Wildenstein Archives, New York; Fratelli Fabbri Editori, Milan; Gravier, Pont-Aven; Henschenverlag, Berlin; H. Hinz-Ziolo; Jos le Doaré, Chateaulin; Mellon; Zauho Press-Ziolo.

Gauguin Copyright © 1972 by Fratelli Fabbri Editori, Milan, Italy
English language text Copyright © 1973 by Fratelli Fabbri Editori, Milan, Italy
All rights reserved

First published in United Kingdom in 1973 by Thames and Hudson, London
Reprinted 1975

ISBN 0 500 86006 8

Printed in Italy

GAUGUIN
IN BRITTANY

by ANDRÉ GIDE

In *Si le Grain ne Meurt* (Gallimard, Paris, 1924) André Gide describes his chance meeting with Gauguin at Le Pouldu in Brittany in 1889, capturing the atmosphere of the village inn run by Marie Henry:

As I was following the seashore, coming up in short stages from Quiberon to Quimper, I arrived one day toward evening in a small village: Le Pouldu, if I am not mistaken. This village consisted of only four houses, two of these being inns. The more modest of the two seemed the pleasanter to me, so I went in since I was very thirsty. A maidservant showed me into a large room with whitewashed walls, where she left me with a glass of cider. The

Fields at Le Pouldu, 1890. Canvas, 28³/₄ × 36¹/₄ in. Washington, D.C., The National Gallery of Art, Paul Mellon Collection.

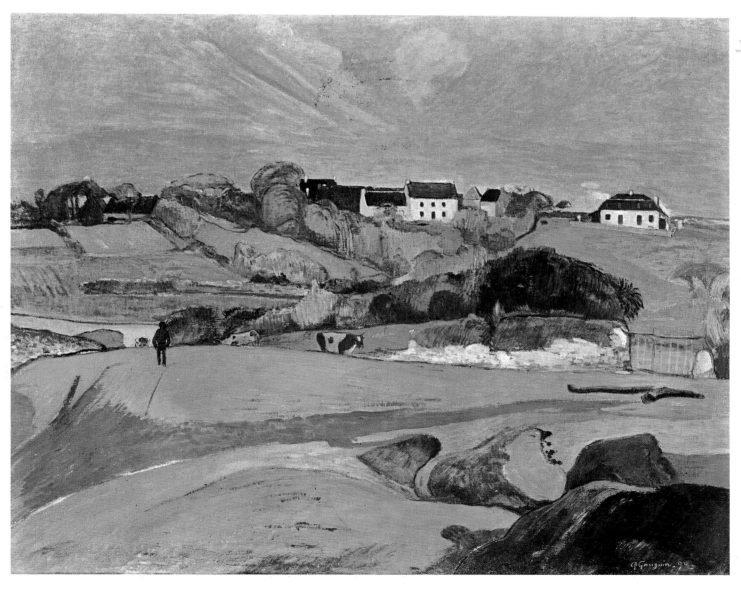

sparseness of furniture and absence of curtains made me keenly aware of quite a large number of canvases and stretchers lying about on the floor, stacked against the wall. No sooner was I alone than I darted toward these canvases; one after another, I turned them round and gazed at them with growing astonishment. It seemed to me that they were only childish daubs of color, but of such vivid, special, and joyous tones that I thought no further of leaving again. I wished to meet the artists capable of producing these entertaining follies. I gave up my original plan of going to Pont-Aven that same evening, took a room in the inn for the night, and inquired when dinner would be served.

« Would you like to be served separately, or will you eat in the same room as those gentlemen? » asked the servant. « Those gentlemen » were the painters of these canvases. There were three of them, who soon turned up with all their paintboxes and easels. Needless to say, I had asked to be served along with them, provided it would not disturb them. But they indicated that my presence did not embarrass them in the least; in other words, they were thoroughly at ease. All three of them were barefoot and superbly sloppy, with ringing voices. During the entire meal I was on tenterhooks, drinking in their words, torn by the desire to speak to them, to introduce myself, to learn who they were, and to tell that tall, bright-eyed fellow that the tune which he was singing at the top of his lungs and which the others picked up in chorus was not by Massenet, as he thought, but by Bizet.

Later I met one of them at Mallarmé's place: it was Gauguin. Another of them was Sérusier; and I have not been able to identify the third (Filiger, I think).

LETTER TO GAUGUIN

by AUGUST STRINDBERG

Before leaving Europe permanently, early in 1895 Gauguin asked Strindberg to write a presentation for the catalogue for a sale of his paintings held in the Hôtel Drouot auction rooms in Paris that February. The great Swedish playwright declined, but his letter of reply showed so much insight into the artist's work and its contemporary setting that Gauguin decided to use it anyway for the introduction. Here are some of its most discerning passages:

You insist on having your catalogue preface written by me in remembrance of this winter of 1894–1895 we are spending here, behind the Institut, not far from the Panthéon, and above all near the Montparnasse cemetery. I would gladly have given you this token remembrance to take with you to that South Sea island where you are going to look for surroundings in harmony with your powerful stature . . . but I feel myself in an equivocal position from the start and reply at once to your request with « I cannot » or, more bluntly, « I do not wish to. »

But I owe you an explanation for my refusal, which does not mean I am unwilling to oblige or that my pen is sluggish. . . .

Here it is: I cannot understand your art and I cannot like it. (I really can't get a grip on your art, now so exclusively Tahitian.) But I know this admission will neither surprise nor hurt you, because you seem to me to be especially fortified by an aversion to others; your personality, so determined to remain inviolate, takes pleasure in the dislike it arouses. And perhaps with good rea-

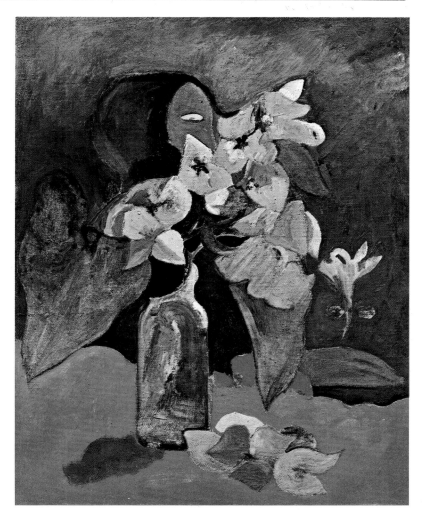

Still Life with Flowers and Idol. Canvas, 16×13 in. Private collection.

son, for from the moment you were to be admired and approved you would have a band of partisans; you would be classified and pigeonholed and your art would be given a name which, five years hence, the young would use as a stock term to designate an outdated art, which they would do all they could to make even more old-fashioned.

I too have tried hard to pigeonhole you,

to insert you as a link in the chain, in order to understand the history of your development—but in vain. . . .

Last night, to the southerly strains of the mandolin and guitar, my thoughts turned to Puvis de Chavannes. I saw on the walls of your studio that jumble of sun-filled pictures that haunted me all night long in my sleep. I saw trees that no botanist would ever find, animals that Cuvier never dreamed of, and men that you alone have been able to create. A sea that flowed out of a volcano, a heaven in which no God can dwell. « Sir, » I said in my dream, « you have created a new earth and a new heaven, but I am not at home in the world of your creation. It is too sunny for me; I like the play of light and shade. And in your paradise there lives an Eve who does not answer to my ideal, for I have an ideal or two of my own about women! »

This morning I went to the Luxembourg Museum for a look at Puvis de Chavannes, who kept coming to mind. I gazed with deep sympathy at his *Poor Fisherman*, so intent on watching for the prey that will earn him the faithful love of his wife who is picking flowers and of his idle child. And how very fine it is! But then I come up against the fisherman's crown of thorns. I hate Christ and crowns of thorns. I hate them, Sir—let that be well understood. I want none of this pitiful God who meekly accepts affronts. My God, rather let it be Vitsliputsli then, he who eats men's hearts in the sun. No, Gauguin was not made from the rib of Chavannes, nor from that of Manet or Bastien-Lepage. Who is he, then? He is Gauguin, the savage who despises a troublesome civilization, something of a Titan who, jealous of the Creator, in his spare moments makes little creatures of his own; he is the child who takes apart his toys and makes new ones from the pieces; he is one who repudiates and defies, preferring to see a red sky of his own rather than the blue one of the common herd.

Well, having worked myself up in the course of writing this, it would almost seem that I'm beginning to understand something of Gauguin's art. After all, one modern writer has been criticized for not depicting real people but instead merely fabricating his characters himself. Merely!

Bon voyage, Master; come back and see me again. Perhaps by then I shall better understand your Art and so be able to write a real introduction to another catalogue for some other Hôtel Drouot, for I too begin to feel an immense need to become a savage and create a new world.

Paris, 1 February 1895

LIFE AND WORKS

1 - PRELUDE

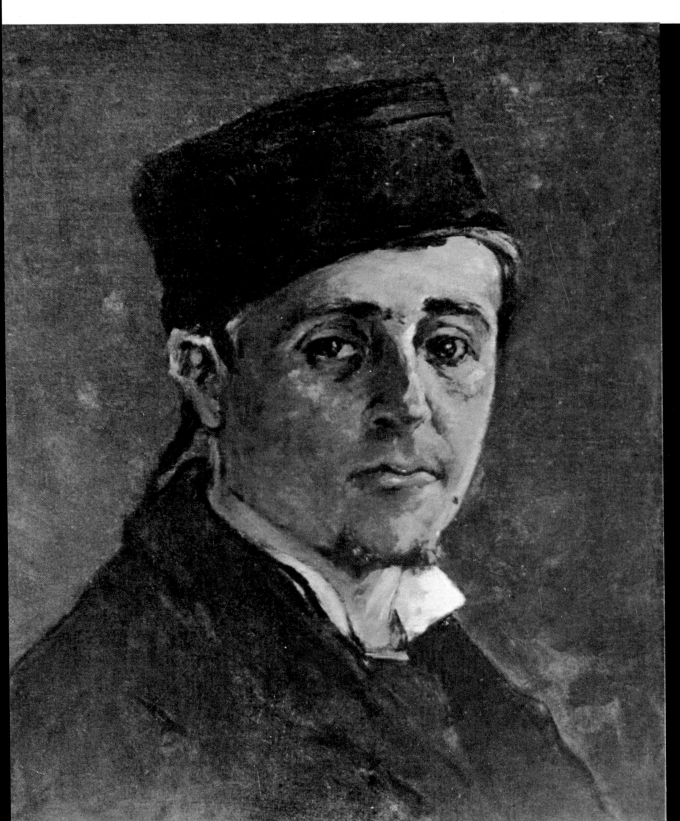

Man with a Cap
(probably a self-portrait),
1877. Canvas, 18 × 15 in.
Private collection.
(Photo Henschenverlag,
Berlin)

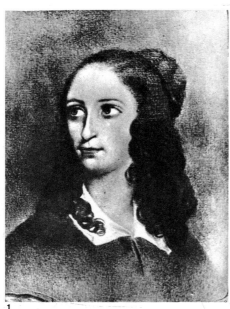

1

The course of a man's life may be decisively shaped by what at the time appear to be chance events or incidental character traits. Later on, when the consequences have resolved themselves, these events or personality factors seem instead to be part of a logical, pre-established pattern from which there was no escape. This apparent inevitability is especially striking in the case of men with ideas and aims of their own, who sacrifice everything to them, and whose achievement is seen in the end to have depended on an unforeseeable confluence of circumstances. Such was the case with Gauguin. Everything we know about his birth and family background seems to have had a determining influence not only over his character but also on the events of his life. With him, heredity obviously accounts for a great deal: it looms large in his temperament, his intellectual makeup, and his behavior. But other factors beyond his control were also at work: political events, social conditions, and philosophical trends. These, too, were entanglements from which he never

broke free, even when he believed himself most independent of them. Blood and background predisposed him to assert himself and long for freedom at a time when, paradoxically enough, in the name of freedom men were being subjected to fresh constraints, for the political revolutions kindled by popular aspirations had only resulted in a transfer of power to the bourgeoisie, whose interest then lay in maintaining the established social order. On his mother's side Gauguin sprang from a family with hot blood in its veins and an exotic background, to which he owed his fierce pride, independent spirit, and temperamental violence. His maternal grandmother was Flora Tristan, a writer and social agitator of some notoriety in the early nineteenth century. Born in Peru in 1803, the daughter of Don Mariano Tristan y Moscoso, she came of a distinguished Spanish Peruvian family; one member of it is said to have been viceroy of Peru and, later, president of the Peruvian republic. Taken to France by her mother, a Frenchwoman, Flora married the engraver André François Chazal in 1821. But a few years later she left him and began an independent, even adventurous existence as a crusading feminist and socialist. In his reminiscences Gauguin has described her as follows:

"Proudhon called her a woman of genius. ... She went in for socialism and set up trade unions. The grateful workers erected a monument to her in the Bordeaux cemetery. She probably knew nothing about cook-

ing. A socialist bluestocking and anarchist. Together with Father Enfantin, she is supposed to have established workmen's clubs and founded a religion called Mapa, Enfantin being the god Ma and she herself the goddess Pa. To sift truth from falsehood is more than I can manage, and I give you all this for what it is worth. She died on November 14, 1844, and many delegations followed her coffin."

"What I do know for certain, however, is that Flora was a very pretty and noble lady. ... She employed her whole fortune in the workers' cause and was continually traveling, even going to Peru to see her uncle Don

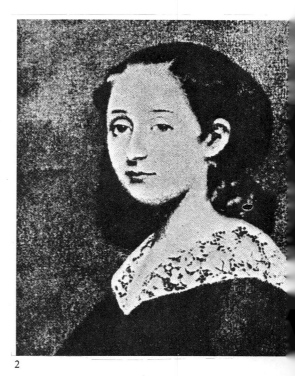

2

1 Flora Tristan, Gauguin's grandmother. Tahiti, Gauguin Museum.

2 Photograph of Gauguin's mother from which he painted the "Portrait of the Artist's Mother."

3 Portrait of the Artist's Mother. Canvas, 16 × 13 in. Stuttgart, Staatsgalerie.

12

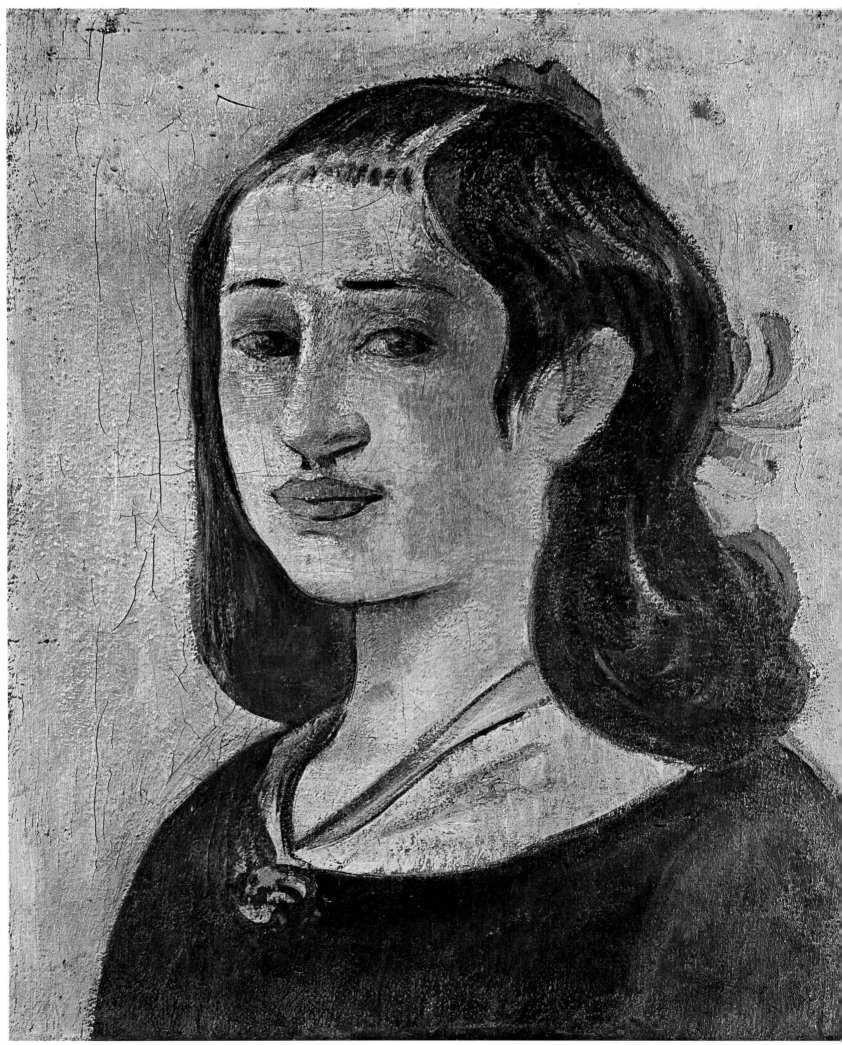

3

1

2

Pio de Tristan de Moscoso (family of Aragon). ..."

Chazal kept trying to persuade Flora to come back to him. In 1838 there was a violent scene between them, and he shot and seriously wounded her; for this he was condemned to twenty years' hard labor. A daughter had been born to them in 1825; named Aline, in 1846 she married Clovis Gauguin, a journalist from Orléans. They had two children, Marie and Paul, who was born in Paris on June 7, 1848.

The February Revolution of 1848 brought Prince Louis Napoleon Bonaparte to power and prepared the way for the Second Empire, founded in 1851. As a radical, Clovis Gauguin was opposed to the new government, and may have foreseen that opposition of any kind would soon become dangerous. Whatever the reason, in 1849 he decided to leave France with his family and go to Peru, where his wife had connections that might prove helpful. They sailed in October 1849, but during a call at Port Famine in the Straits of Magellan, Clovis Gauguin died

3

suddenly of a heart attack. Aline with her two small children continued the voyage to Lima, where she was given a cordial welcome by her great-uncle Don Pio. So from his earliest years Paul Gauguin began the wandering life which circumstances imposed on him and which, again and again, involved a marked break with the past. His whole life was checkered by abrupt and fateful changes, being sometimes of his own choosing and sometimes beyond his control.

In 1855, following the death of Paul's paternal grandfather Guillaume Gauguin in Orléans, Aline left the pleasant life she had enjoyed in Peru and returned with her children to France. They settled in Orléans, where they made their home with Isidore Gauguin, Aline's brother-in-law. Young

1 Photograph of Mette Sophie Gad in 1873,
shortly before her marriage with Gauguin. Tahiti, Gauguin Museum.
2 Mette Gauguin, 1878? Canvas, 45⅝ × 31⅞ in. Zurich, E. G. Bührle Foundation.
3 Gauguin in a photograph of 1873, the year of his marriage.

The Seine with the Pont d'Iéna, 1875. Canvas, 25¹/₂ × 36¹/₄ in.
Paris, Musée du Louvre, Jeu de Paume.

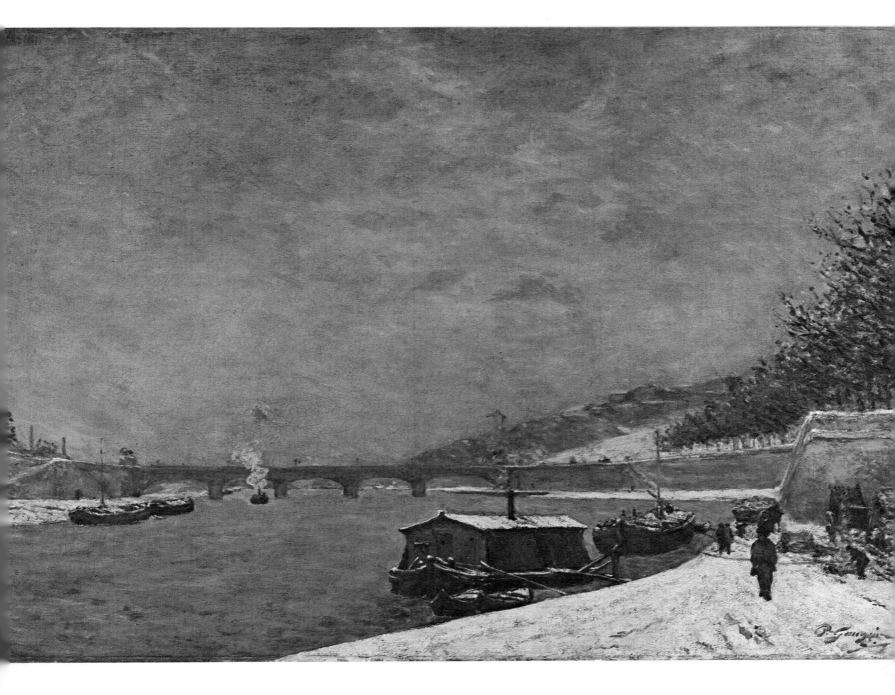

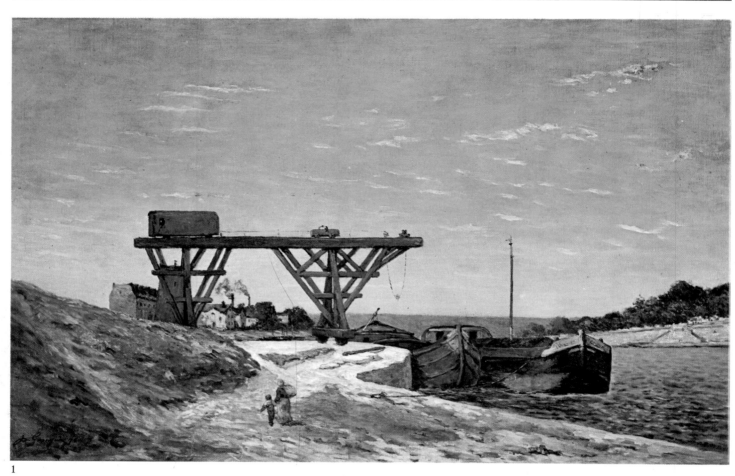

1

Paul was sent to school there, but he was different from the other boys, as the schoolmaster seemed to recognize when he said of him: "That boy will be either an idiot or a genius." At eleven he entered a secondary school staffed by priests, where he was not happy. He later wrote: "It was there I learned ... to loathe hypocrisy, bogus virtues, and informing ... to be on my guard against whatever runs counter to my instincts, heart, and reason."

At seventeen he took the entrance examination for the Naval Training School, but failed. Deciding to go to sea anyway, he signed up on December 7, 1865, as a pilot's apprentice in the merchant marine. For the next few years he sailed the

Atlantic and the Pacific, and when it came time to do his military service in 1868, he was transferred to the navy. He served in the navy for the next three years, including during the Franco-Prussian War of 1870–1871. Discharged on April 23, 1871, he found himself at twenty-three, in Paris, a free man but without a job and even without a profession.

His mother had died in 1867, but in her will she had appointed a guardian for him, a banker named

Gustave Arosa, who had been a friend of Flora Tristan. Through him Gauguin obtained a clerk's job with the Paris broker Bertin, where he worked for the next ten years, earning a good living and speculating successfully on the stock exchange. Arosa was a cultivated man and a collector, and during weekend visits to his house in St-Cloud Gauguin was able to familiarize himself with a good collection of contemporary paintings which (as we know from the sale held in February 1878 after

1 The Seine between Pont d'Iéna and Pont de Grenelle with the Cail Works, 1875. Canvas, 31⁷⁄₈ × 45⁵⁄₈ in. U.S.A., Private collection.

2 Apple Trees in Blossom, 1879. Canvas, 34⁵⁄₈ × 45¹⁄₄ in. U.S.A., Private collection.

2

Arosa's death) included nine works by Corot, seven by Courbet, twelve by Delacroix, three by Diaz, six by Jongkind, and five by Tassaert.

In a pension near the Bourse where he sometimes took his meals, in the spring of 1873 Gauguin met a young Danish girl, Mette Sophie Gad, and they were married that November.

Between then and 1883 they had five children: Émile, Aline, Clovis, Jean, and Pola. They lived at first in an apartment in the Impasse Frémin off Rue des Fourneaux (now Rue Falguière) and then, from the spring of 1879, in a comfortable suburban house with a garden near the church of Vaugirard.

2 - BIRTH OF A VOCATION

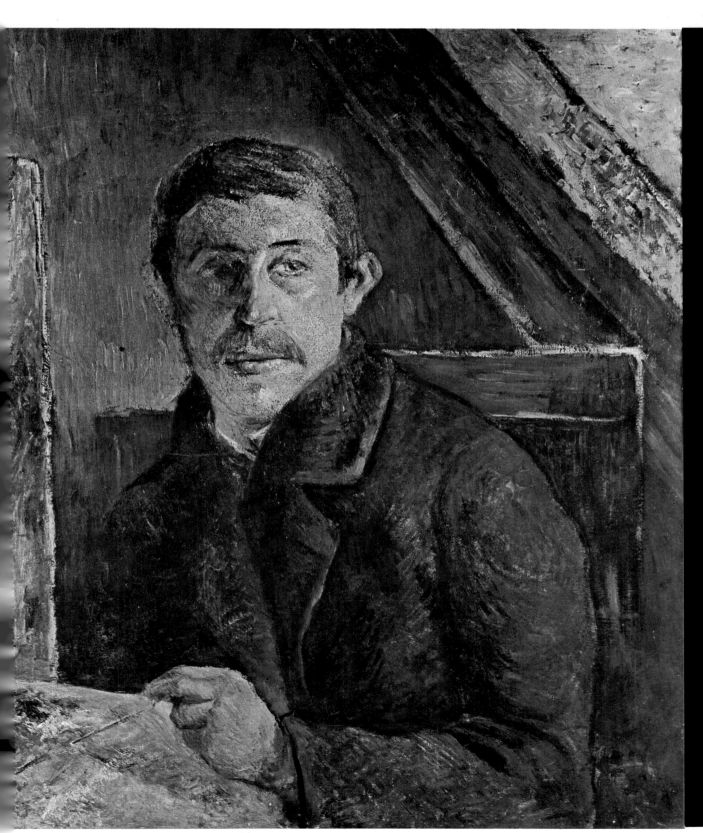

Self-Portrait
at the Easel, 1885.
Canvas, $25^1/_2 \times 21^1/_4$ in.
Bern, Collection of
Jacques C. Koerfer.
(Photo H. Hinz-Ziolo)

Gauguin had learned the rudiments of drawing before his marriage. Afterward, in his spare time and during frequent stays at St-Cloud with the Arosa family, accompanied by Mette and her friend Marie Heegard, he continued to draw and began to paint. He took an interest in the Impressionist movement, which had been in the news since 1874, and even began to buy some canvases by those young revolutionaries Cézanne, Sisley, Pissarro, and Degas.

In 1876, he chanced submitting to the official Salon one of his first paintings, a landscape done the year before at Viroflay, and it was accepted. He also tried his hand at sculpture, taking lessons from the sculptor Bouillot, who lived next door in Rue des Fourneaux. He modeled in clay and soon was working directly in marble. It was with

a statuette that Gauguin's work was discreetly represented for the first time at an Impressionist exhibition; this was the fourth, in 1879. From 1880 on, his participation in their group exhibitions became regular and more substantial; that year he showed seven paintings and one marble. In 1881 he was represented by eight paintings and two sculptures, and in 1882 by twelve paintings and one sculpture. At the last Impressionist exhibition in 1886 he showed nineteen paintings. In the space of only a dozen years or so, this Sunday painter of the 1870s had revealed himself to be one of the most original artists of his time.

In reviewing the 1881 exhibition, the novelist J. K. Huysmans singled out Gauguin's work for praise and commented at length on his large *Study of a Nude*: "I do not hesitate to assert that among contemporary painters who have worked at the nude, not one has yet been able to render it with such vehement realism. ... Gauguin is the first artist in years who has attempted to represent the woman of our own day. ... His success is complete, and he has created a bold and authentic canvas."

In 1883 Gauguin resigned from his position with the brokerage firm of Bertin. The circumstances of the moment probably led him to take that decision. There had been a bad financial crash in 1882, and the business world had not yet recovered. His position at Bertin must have seemed uncertain, and so he let it go on the assumption that, by devoting all his energies to painting, he would be able to make a living from it. One of his friends and colleagues, Émile Schuffenecker, had

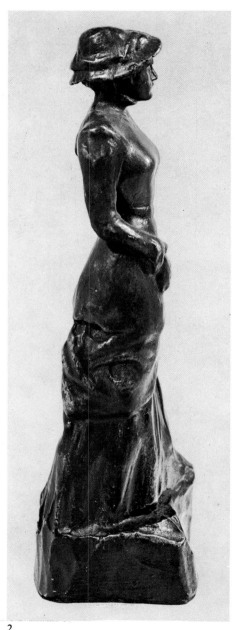

just taken the same decision. In the years to come, "Schuff" proved himself a true friend, lending Gauguin money when he needed it most and putting him up when he was

1 Camille Pissarro: Gauguin Carving The Little Parisienne, 1880–1881. Drawing. Stockholm, Nationalmuseum.

2 The Little Parisienne. Bronze, height 10⅝ in.

1 Gauguin's son Émile in his nurse's arms, photograph of 1875.

2 Study of a Nude (Suzanne Sewing), 1880. Canvas, 45¼ × 31½ in. Copenhagen, Ny Carlsberg Glyptotek.

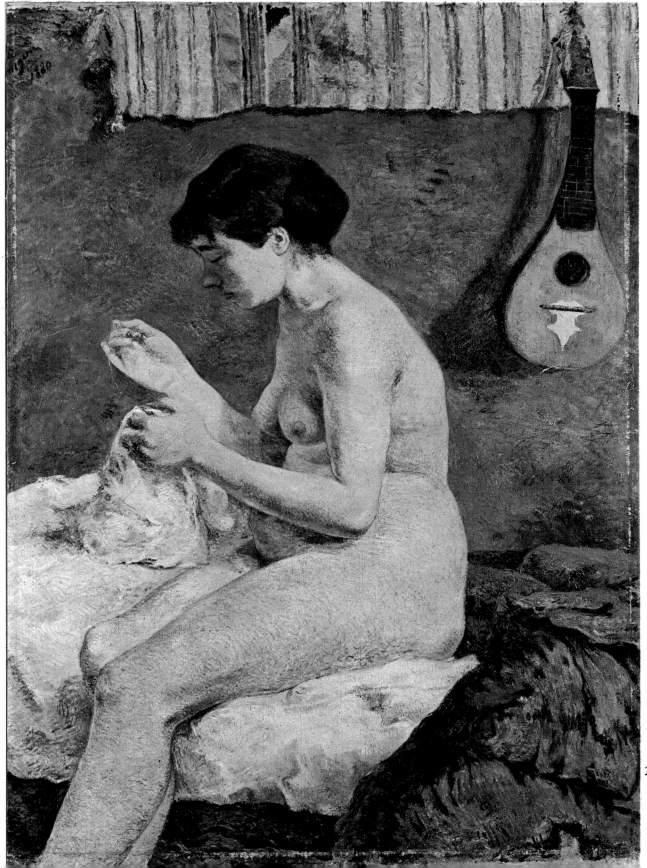

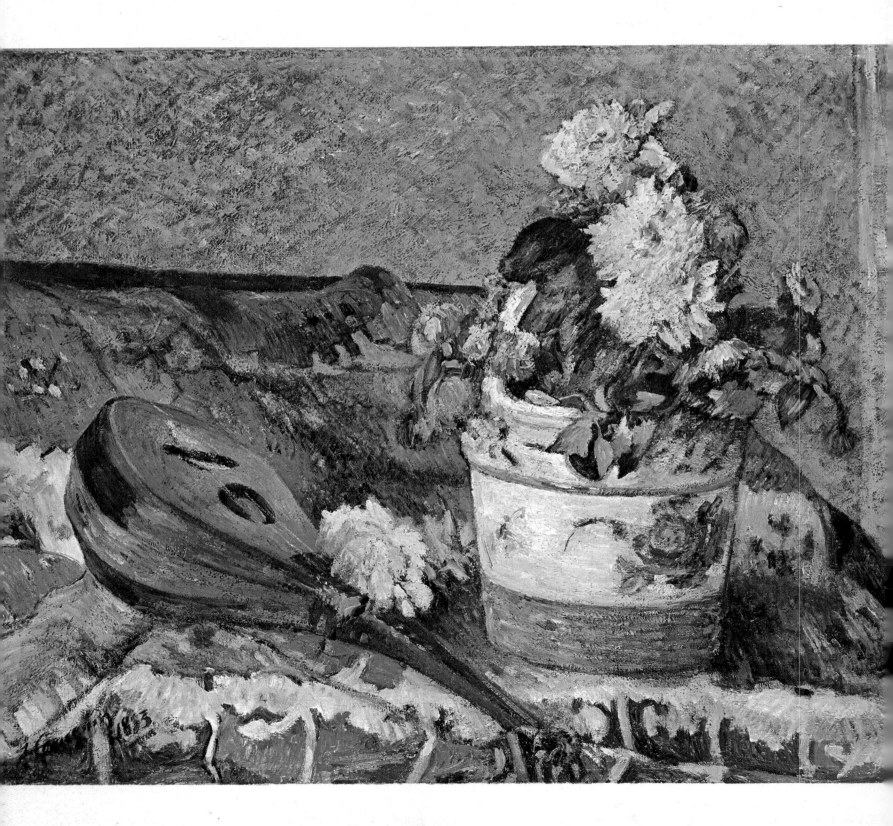

Mandolin and Pot of Flowers, 1883. Canvas, 18×21⅝ in. U.S.A., Private collection.

1 **Still Life with Tomatoes, 1883. Canvas, 23¹/₂ × 28³/₄ in. Collection of Mrs. J. Bernhard.**

2 **Still Life with Profile of Charles Laval, 1886. Canvas, 18¹/₈ × 15 in. Collection of Mrs. Walter B. Ford II.**

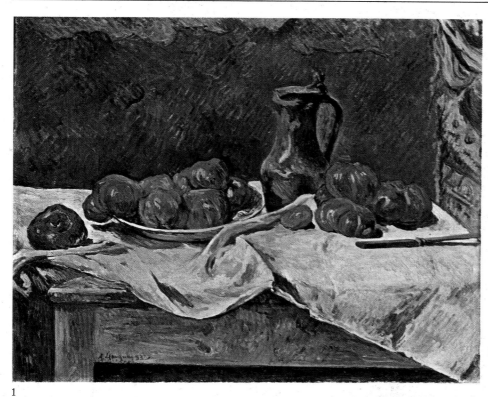

1

manufacturer of weatherproof canvas and tarpaulins, items he hoped to sell to Danish shipbuilders. But he failed to find a market for them, and again painting appeared to be the only possible solution for him. But he was not in his element with the Gads or his wife's friends who came to the house. Prudent, respectable, conventional-minded, and bourgeois to the core, they were shocked by his free-and-easy ways, his disregard for all convention. Attitudes that were natural to him seemed deliberately provocative to them.

The truth is that Gauguin was a proud and unbending man. He probably did little to gain the good will of his Danish in-laws and their circle of friends, whose tastes and ideas it was impossible for him to share. He seems to have gone out of his way to make himself disagreeable

homeless. But the immediate results of his choice were disappointing, for business was no better in the art world than on the stock exchange. His work did not sell; with a wife and five children to support, the little money he had saved melted away rapidly. But he stuck to his decision, not only because no better alternative presented itself but also because he was now possessed by a passion for painting from which nothing could deflect him.

Pissarro, whom he had met in Arosa's house and whose background had some of the same exoticism of his own (he came from the Danish West Indies), had been instrumental in getting Gauguin accepted as a member of the Impressionist group. Always interested in new talent, generous with advice and help, and faithful to his art though it earned him only the barest livelihood, Pissarro was a living example of the

dedicated artist to Gauguin and strengthened his own resolution to persevere. Together they went out painting landscapes in the vicinity of Pontoise, at Osny in particular.

In the hope of finding buyers for his pictures and a lower cost of living, Gauguin moved to Rouen with his family at the end of 1883. No more successful there than in Paris, he failed to sell a single painting. Since he could not support his family by his art in France, he agreed to Mette's proposal that they go to Denmark, where it would be easier to find help and patronage through her family, who had good connections. Their remaining furniture, pictures, and linen were packed up and sent off, and Mette left with the children for Copenhagen at the end of October 1884. Gauguin joined them there in early December. Before leaving Rouen he obtained an appointment as representative in Denmark of Dillies & Co., a French

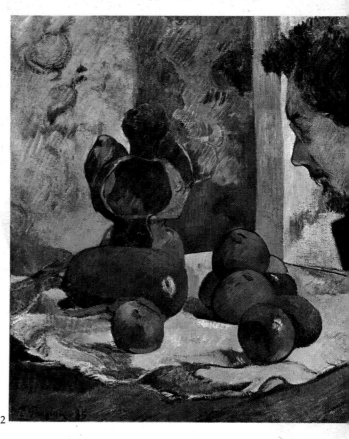

2

to them. One day, while his wife was receiving some friends in the drawing room, he is said to have come in wearing only a shirt, taken a book from the shelf, and then coolly walked out again ignoring them all. It very soon became clear that Gauguin would never get on with the Danes. The situation is well summed up in the biography by his son Pola: "The welcome Gauguin received in Denmark was not exactly cordial, and this was not surprising. The eldest daughter, of whom the family was so proud, married to a Paris stockbroker, comes home disappointed, embittered, humiliated, escorted by many offspring, and bringing with her a husband whose sole resource was a future prospect, which he had to create for himself. The family circle received him politely, with forced civilities, and maintained an expectant attitude. ... Certainly, too, the barrier raised by a foreign language which he only half understood, together with the differences in manners and customs, did not make things any easier for Gauguin either in his business undertakings or in his relations with the family."

As a commercial traveler dealing in tarpaulins, Gauguin was a failure in Denmark. As a painter he did no better. He managed to arrange an exhibition of his pictures in the gallery of the Friends of Art in Copenhagen, in May 1885, but this aroused no interest whatever. Humiliated by this failure and disgusted with the Danes, he decided to return to France. He left in June, taking with him his favorite son, six-year-old Clovis. Mette stayed in Denmark with the other four children, supporting herself by doing translations and giving French lessons.

Arriving in Paris, Gauguin stayed first with Schuffenecker in Rue Boulard, then with another friend in the

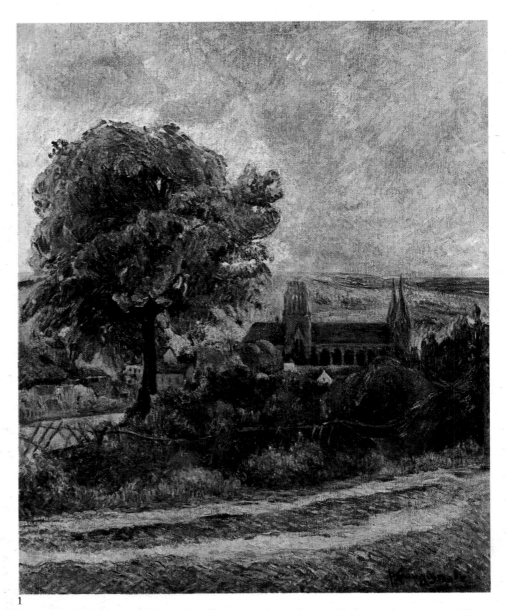

1

Impasse Frémin, off Rue des Fourneaux. After brief visits to London and Dieppe, he was again with Schuffenecker in late September. Several paintings testify to his stay in Dieppe, but none to his presence in London, which is only known to us from a letter to his wife written on September 19, 1885: "Since my

last letter I have been traveling. I have just arrived here in Dieppe, where I intend to stay two or three days before spending nearly three weeks in London, you know where. As you must have seen in the Copenhagen papers, the Spanish business has become more involved, and that of course will give a push to the

1 **Rouen, Church of Saint-Ouen, 1884. Canvas, $35^3/_8 \times 28^3/_4$ in. U.S.A., Private collection.**

2 **Pond with Cattle, 1885. Canvas, $31^7/_8 \times 25^1/_2$ in. Milan, Galleria d'Arte Moderna.**

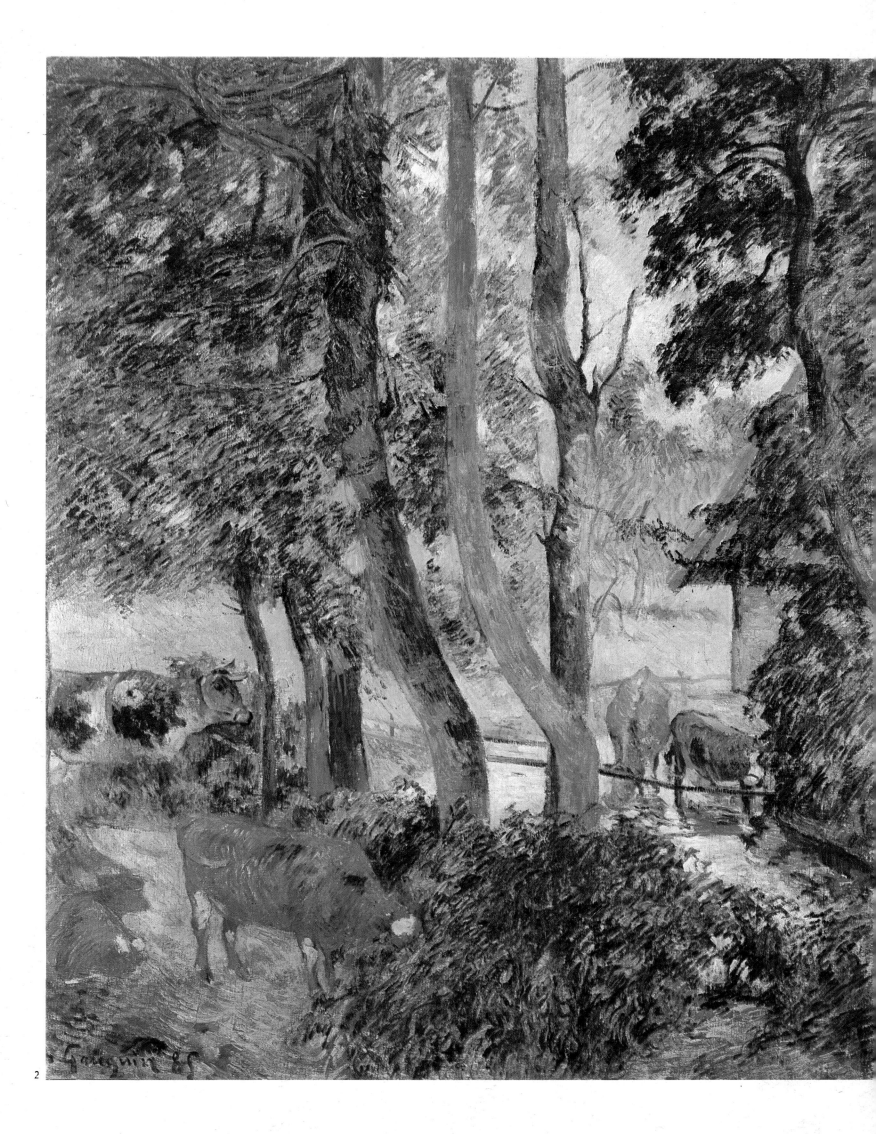

2

Asters on a Bureau, 1886. Canvas, 23$\frac{1}{2}$×28$\frac{3}{4}$ in.
Collection of Mrs. Frank Jay Gould.

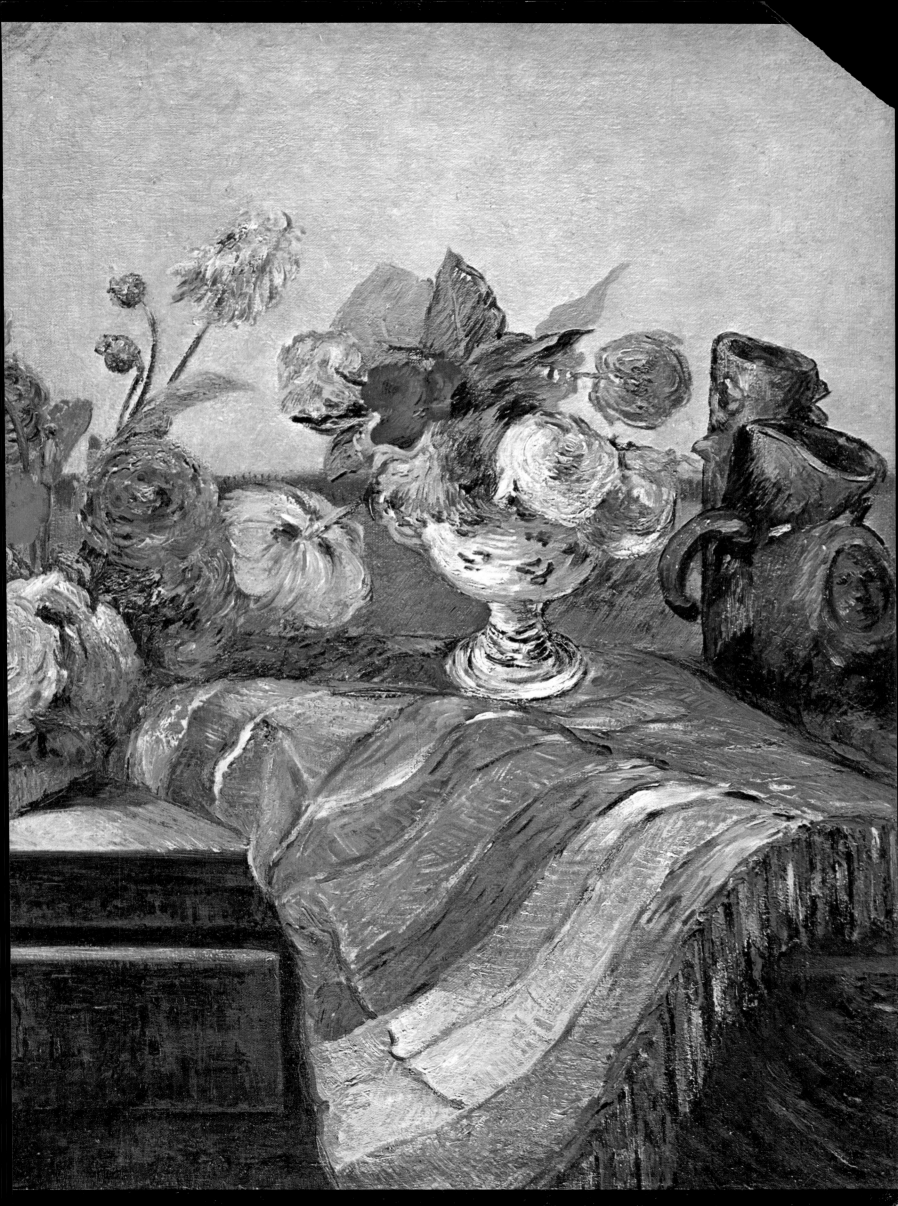

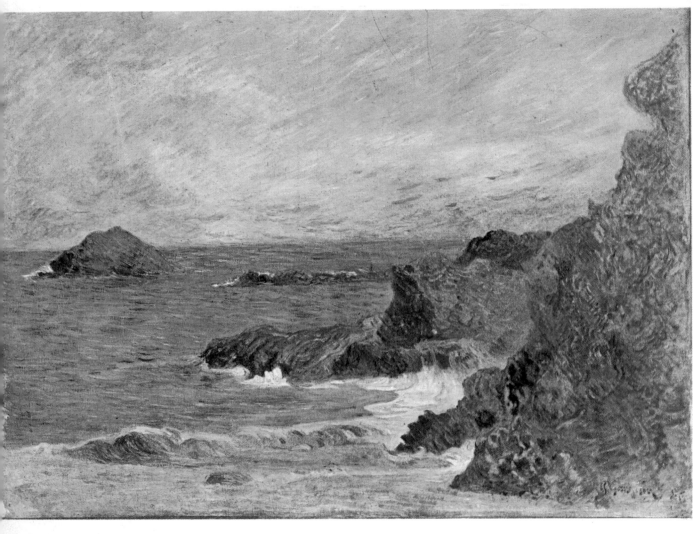

**Breton Coast, 1886.
Canvas, 27⁷/₈×36¹/₄ in.
Göteborg,
Konstmuseum.**

turn of affairs we were hoping for. So it is only a question of time, and I have not neglected to go and renew the friendship previously made."

It has been assumed—though no proof has ever been forthcoming—that this letter and the mysterious trip to London relate to political activity of some kind, in connection with a trip to Spain he apparently made in 1883. Whatever the significance of this episode, it seems to have had no further bearing on the artist's life. Back in Paris that October, he took a wretched room in

Rue Cail, near the Gare du Nord. That winter was a period of great poverty and distress for him; practically penniless, he was reduced to taking a job as a billsticker. "The weather here is cold; there is snow on the ground, and I sleep on a bare board huddled in my traveling rug." These privations were too much for Clovis, and he became ill. "When the boy came down with smallpox, I had twenty centimes left in my pocket and had been eating stale bread on credit for three days. In my panic it occurred to me to apply to a railway advertising company

for a job as a billposter. My bourgeois appearance made the manager laugh. But I told him earnestly that I had a sick child and needed work. So I pasted advertisements for five francs a day. While I did so, Clovis was confined to his bed with fever, and in the evening I would come home to look after him."

Clovis recovered, but otherwise the year 1886 brought no change for the better. Gauguin's relations with his wife Mette became embittered. Yet he went on painting. In May, at the eighth and final Impressionist exhibition, he showed nineteen can-

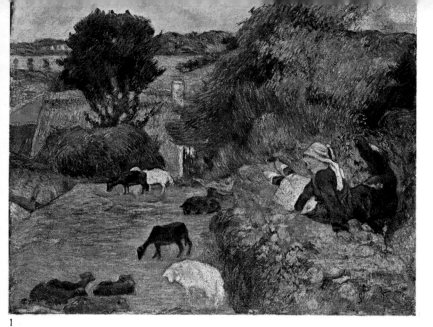

1

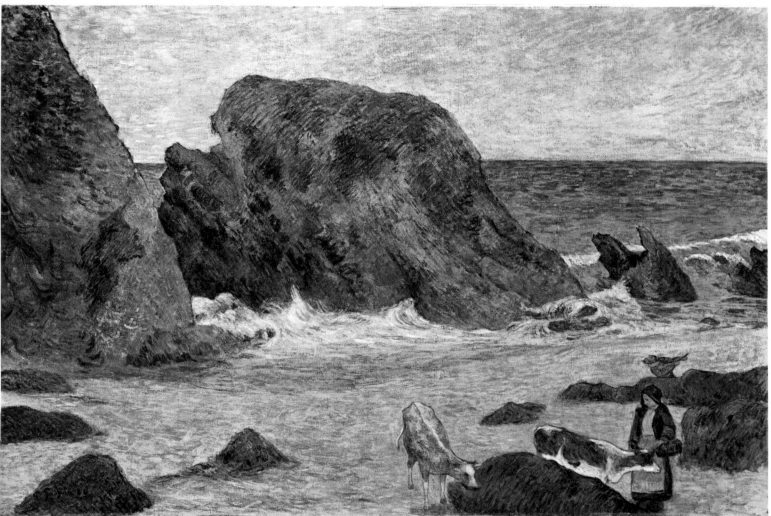

2

vases, most of them done during the previous year. Mainly landscapes, they were admired by the critic Félix Fénéon: "Gauguin's tones are very close to one another, giving a muffled harmony to his pictures. Dense trees stand in rich, moist land ... with water running between the trunks, thick with tangled grass." Through the engraver Félix Bracquemond, he met the ceramist Chaplet,

a meeting that had important consequences, for it marked the beginning of Gauguin's own abundant and highly original ceramic production. In order to live more cheaply, he again decided to leave Paris. "The most reasonable course," he wrote to his wife, "would be to board in Brittany for sixty francs a month." At the end of June 1886, leaving Clovis in a boarding school, Gauguin

went to Pont-Aven in Brittany, to the inn of Marie-Jeanne Gloanec, where artists were sure of a friendly welcome and where, in case of need, credit was sometimes extended. He arrived there with a conception of painting still close to the Impressionist aesthetic, with a body of work behind him indicative of his gifts and a technique sufficiently developed to reflect his strong personality. Pont-Aven was to be a turning point in Gauguin's life— again brought about as much by outside circumstance as by any conscious decisions taken by the artist himself.

1 **Breton Shepherd Girl, 1886. Canvas, 23$\frac{1}{2}$ × 28$\frac{5}{8}$ in. Newcastle-upon-Tyne, By courtesy of the Laing Art Gallery.**

2 **Breton Coast with Girl and Cows, 1886. Canvas, 29$\frac{1}{2}$ × 44 in. U.S.A., Private collection.**

3 - THE REVELATION OF A PERSONALITY

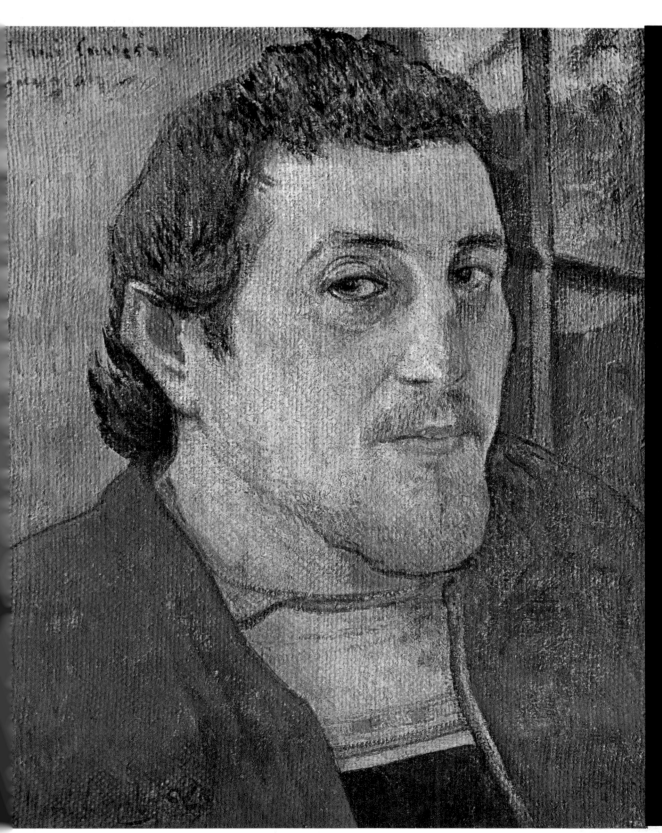

**Self-Portrait Dedicated
to Eugène Carrière, 1890.
Canvas, 15⁷/₈ × 12³/₄ in.
Collection of Mr. and Mrs. Paul
Mellon. (Photo Mellon)**

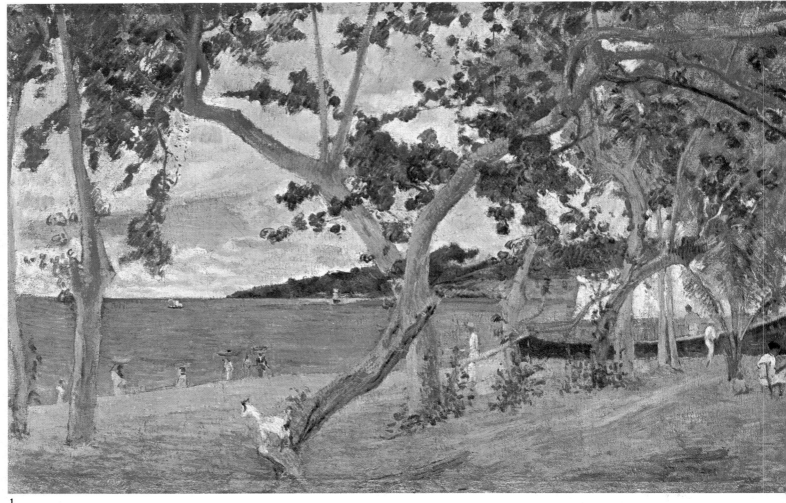

1

In going to a remote village in Brittany, near the desolate Cape Finisterre, Gauguin asserted his need for independence, his need to break away from the bourgeois social order and return to a world of primitive simplicity and elemental truths where an artist's personality could develop freely and find the form of expression best suited to it. He knew now that painting was his ruling passion and was prepared to make any sacrifice and to undergo any hardship to fulfill his destiny as a painter. By now his powerful temperament was asserting itself with an originality that set him apart from others. His technique, it is true, was still that of Impressionism, but he was about to throw off the influence of an art revolution that was not his own, for by the time he joined the group the hardest battles had already been fought and won. Pont-Aven was at that time already an artists' colony, but Gauguin soon established himself as its commanding figure. "I am working hard and successfully," he wrote to Mette. "I am respected as the ablest painter in Pont-Aven. ... Englishmen, Americans, Swedes, and Frenchmen contend for my advice."

Returning to Paris in November 1886, he again went through a difficult winter. In the spring of 1887 he decided to make a complete break and try his luck outside the civilized world. This wanderlust, the call of exotic lands to which he responded again and again, may have been due to lingering memories of his boyhood in Peru and of his youth as a sailor. One thing is certain—the courage, not to say rashness, he showed in setting off on this venture without bothering to take even the most elementary precautions. "I sail on August 10 from Saint-Nazaire. ... I have only just enough for the voyage and won't have any money

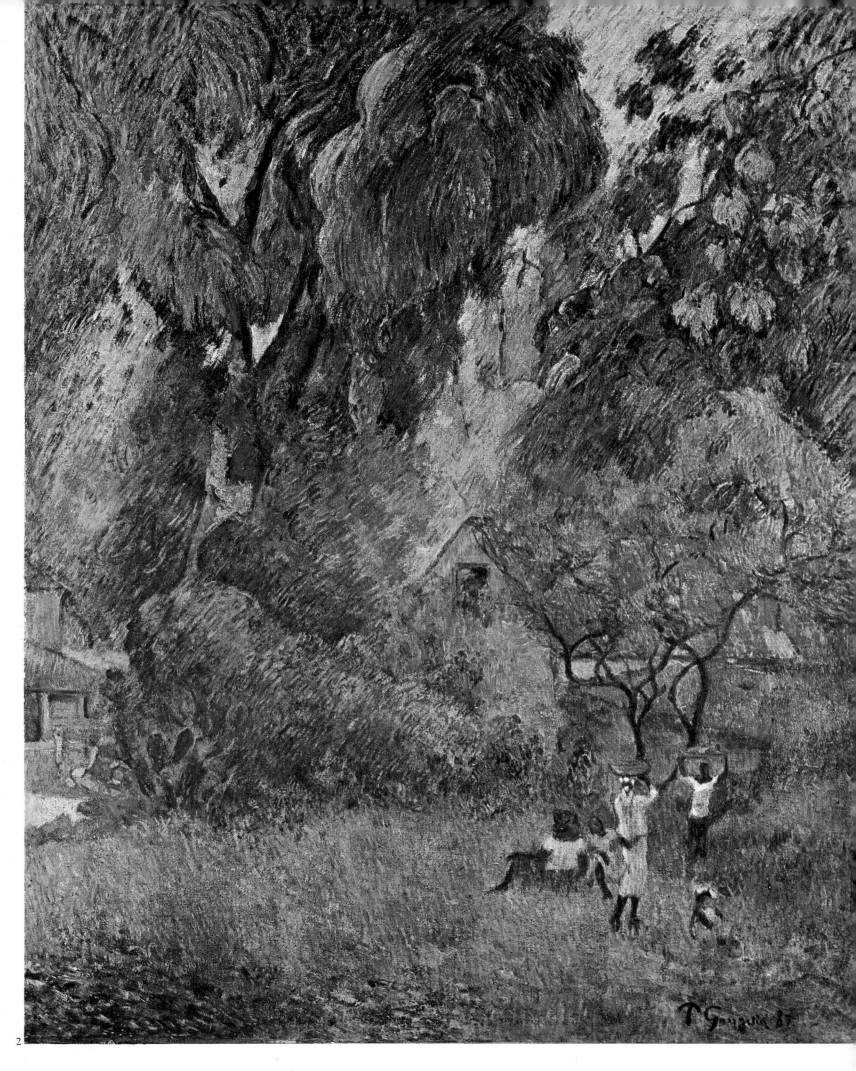

1 By the Seashore (Martinique), 1887. Canvas, 21¹/₄ × 35³/₈ in. Copenhagen,
Ny Carlsberg Glyptotek.

2 Huts under the Trees (Martinique), 1887. Canvas, 36¹/₄ × 28¹/₄ in. U.S.A.,
Private collection.

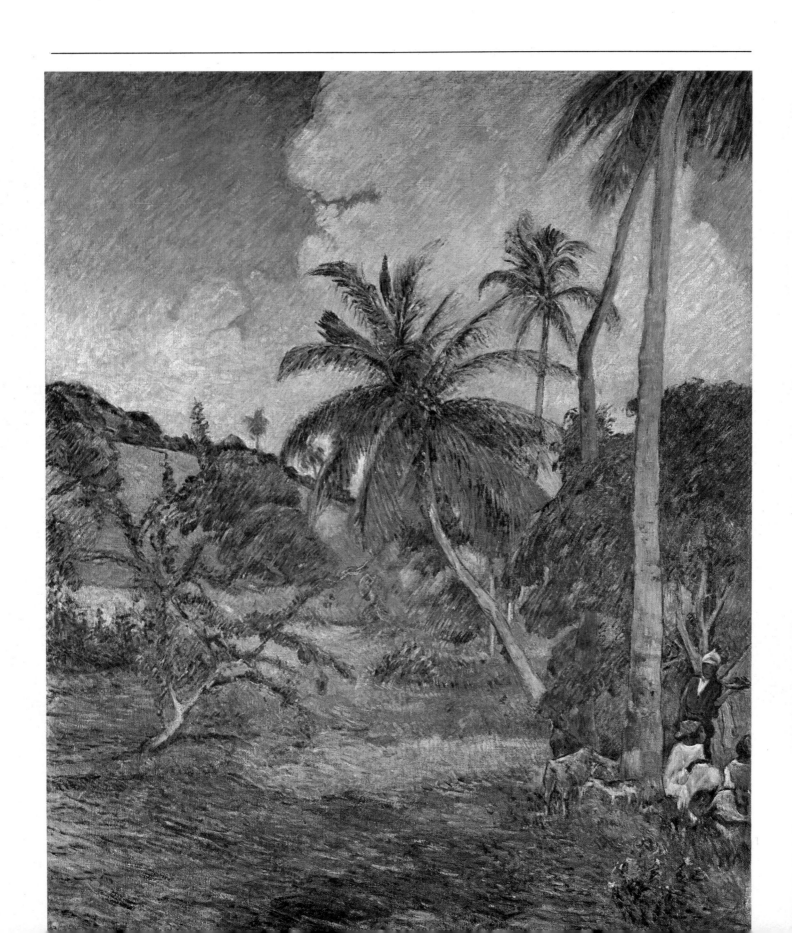

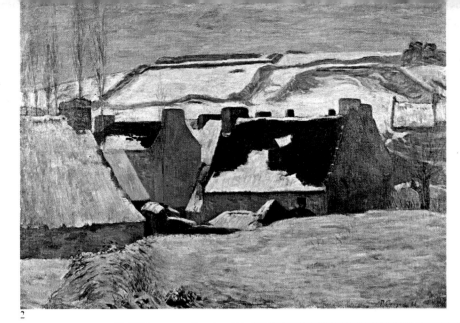

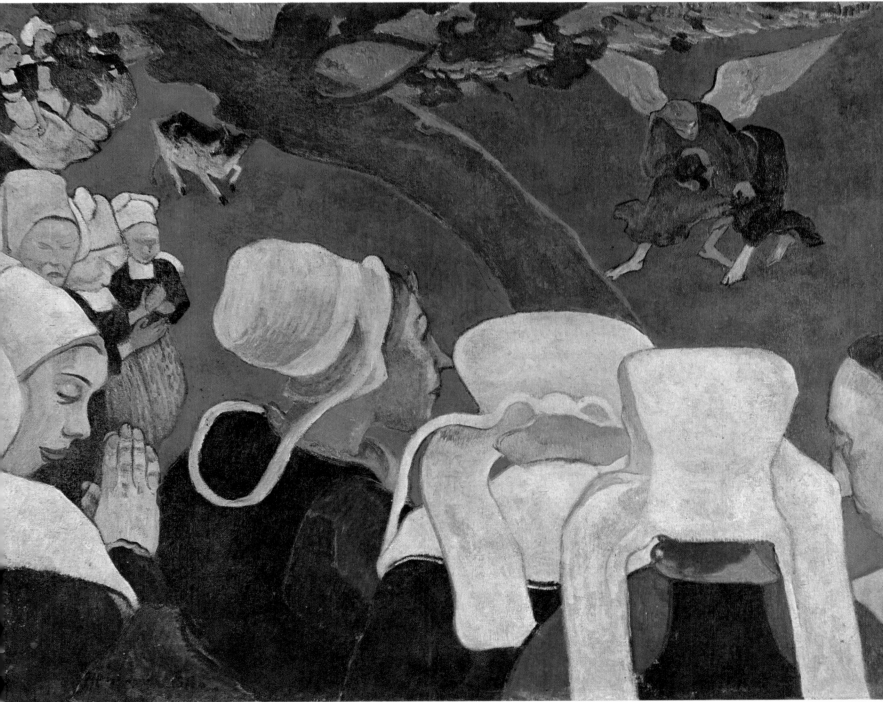

1 Palm Trees in Martinique, 1887. Canvas, 44 × 34¹/₄ in. U.S.A., Private collection.

2 Snow Scene in Brittany, 1888. Canvas, 28⁵/₈×36¹/₄ in. Göteborg, Konstmuseum.

3 Jacob Wrestling with the Angel (The Vision after the Sermon), 1888.
 Canvas, 28³/₄ × 36¹/₄ in. Edinburgh, National Gallery of Scotland.

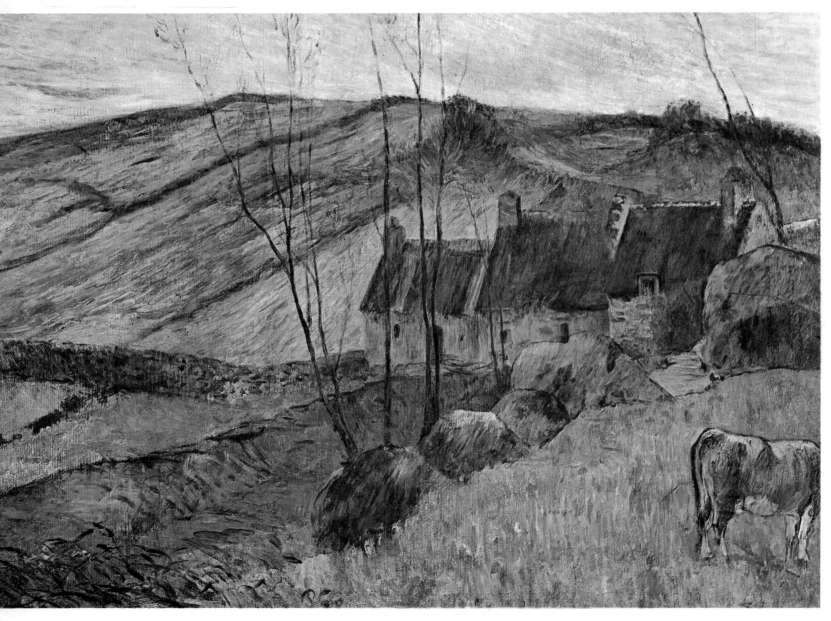

when I reach America. What I intend to do there. ... I don't yet know myself. ... But what I must do above all is get away from Paris. It is a desert for a poor man. My reputation as an artist is growing every day. Meanwhile I sometimes go three days without food, which destroys not only my health but my *energy*. I must get my energy back,

and I'm going off to Panama to live like a native."

But he found that even in exotic places there was no escape from the constraints and money worries of civilization: "Life in Panama, with the building of the canal, has become impossible, even in the most deserted spots. The mountain Indians grow nothing and do nothing,

but they won't let you have a foot of land. Martinique is a fine place where life is easy and cheap." For a few weeks, with his painter friend Charles Laval, whom he had persuaded to join him in this venture, Gauguin worked with the labor gang on the canal diggings. With their earnings they were able to pay the fare to Martinique; but by the time

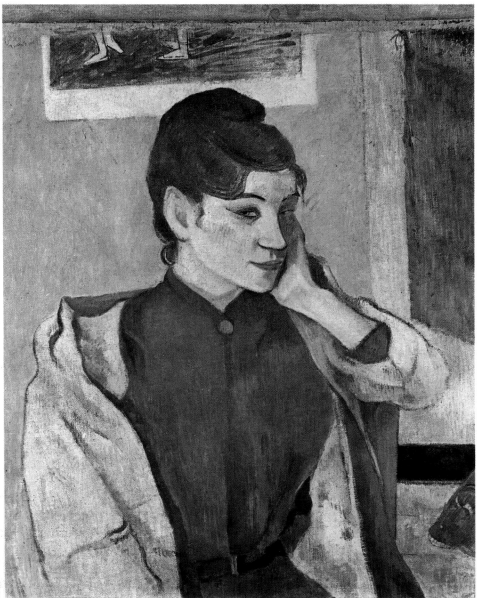

matting, laid low, and I haven't got enough to pay my fare back to France. I'm writing to Schuffenecker asking him to come to the rescue as he has done before." In the end he worked his passage back as a seaman and in November 1887 he reached Paris, where Schuffenecker put him up again.

In spite of its troubles and disappointments, this stay in Martinique was not without importance in Gauguin's career. He brought back about fifteen paintings and many drawings. These begin to show the characteristics which, in the years to come, gave birth to a new style that marked an uncompromising reaction against Impressionism. But he had not yet reached this stage of decisive emancipation and seems to have had no thought of it, for he maintained his former contacts with the artists of Paris. Nevertheless, he was beginning to develop a technique of his own and to make more systematic use of certain procedures, applying his paints not only in small separate daubs of sparkling color, as the Impressionists did, but also in long parallel hatchings. The most important technical advance was the appearance in several paintings of forms rimmed with contour lines, a trait utterly at variance with Impressionist theory and practice. He simplified his palette, adopted warmer tonalities, and went in for more forthright contrasts. Broadly speaking, Gauguin was beginning to move away from a spontaneous art, more or less true to nature, toward carefully organized color patterns owing more to the artist's visual imagination than to nature. This tendency, which had already appeared in some of the paintings done in Brittany in 1886, increased in his Martinique paintings, scenes of local life in which the figures are given increasing prominence in the overall com-

they arrived there in June, landing at the little capital of St-Pierre, they were so short of money they had to sell their watches on the pier to the highest bidder.

For a while things seemed to improve, though soon they were practically penniless again. Gauguin liked the people and the tropical landscape, admired their originality and natural grace. He made many drawings and began to paint, but in August came down with malaria: "I am lying in a Negro hut on seaweed

1 **Paul Sérusier: Portrait of Gauguin (upper left) on a sheet of sketches, 1888. Paris, Boutaric Collection.**

2 **Portrait of Madeleine Bernard, 1888. Canvas, 28¹/₄ × 22³/₄ in. Grenoble, Musée de Peinture et Sculpture.**

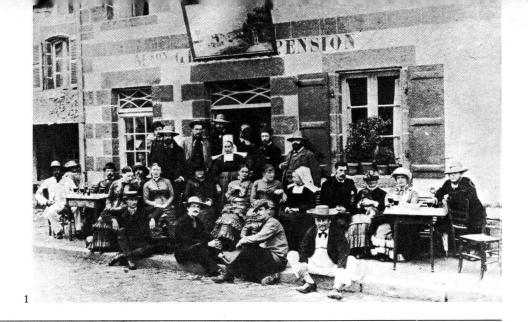

position. It would be a mistake to conclude that he was attracted mainly by the picturesque or anecdotal side of native life. Rather, the exotic subjects he found in Martinique helped him break away from the disciplines of European art and find new personal means of expression. This fresh vision of life set him free and—perhaps unwittingly—revealed him to himself.

It must be remembered that these pictures, with their sunny color schemes, at once grave and serene, were executed at a time of direst poverty and ill health. Gauguin's passionate devotion to his art was such, even then, that no hint of his material worries and bleak prospects appears in his work. Theo van Gogh, Vincent's brother and the manager of the Boussod-Valadon Gallery, arranged for an exhibition of Gauguin's Martinique canvases in January 1888. Both the painter's critics and admirers were somewhat disappointed: "We expected to find new conquests in color, more radiant and more violent effects of sunlight, but in these pictures with their warm heavy shadows, the forms seem purplish and black. The colors are simplified and violently contrasted," wrote Gustave Kahn.

Though it may not have been clear at the time, the Martinique paintings mark a definitive move away from Impressionist naturalism toward that expressive, symbolic, non-imitative use of color which was to characterize Gauguin's most original work. Nor is it by any means certain that Gauguin himself was conscious of having made that move. It is true that, in the next few months, he steadily progressed in this direction, but at the same time he continued to develop what he had learned from the Impressionist aesthetic, as if intent on exhausting all its possibilities before renouncing

1 Group of painters in front of the Pension Gloanec at Pont-Aven, in a photograph of 1888. (Gauguin is seated in the foreground.)

2 Sketch of the Self-Portrait called "Les Misérables," in a letter of October 8, 1888, to Schuffenecker. Private collection.

1 **Portrait of Van Gogh Painting Sunflowers in Arles, 1888.**
Canvas, 28³/₄ × 36¹/₄ in. Amsterdam, Vincent van Gogh Foundation.
2 **Drawing of Van Gogh Painting Sunflowers in the "Huyghe Sketchbook,"**
4¹/₈ × 6¹/₄ in. Paris, Musée du Louvre, Cabinet des Dessins.

it entirely. Apart from the adoption of flat colors and strong contour lines, the most conspicuous change in his work was the greater prominence given to the human figures, even in pictures that were nominally landscapes. This new emphasis on the human presence is particularly important because it adds a spiritual dimension to the painter's conception of the picture. The Impressionists had eyes only for nature and gave no priority to man, who more often than not was reduced to the level of an anonymous silhouette or benchmark. With Gauguin, on the contrary, man again became an active and significant presence, giving animation to the natural scene, whether as a harvester or a stroller. Up to his departure for Tahiti in 1891, the human figure became increasingly prominent in Gauguin's work. But before that time there were further transformations which revealed his true stature and laid the basis for the final flowering of his art.

In February 1888 he went for a second time to Pont-Aven, where he

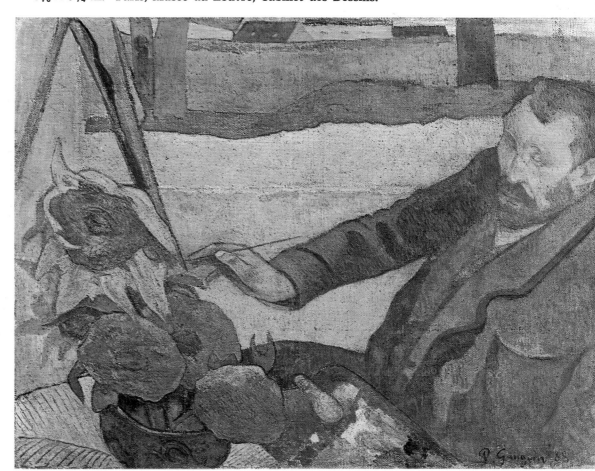

felt in close communion with nature: "I love Brittany: there I find the wild and primitive. When my wooden shoes ring on this stony soil, I hear

the muffled, dull and mighty tone I am looking for in painting." At Pont-Aven he fell in again—this time decisively—with a young painter named Émile Bernard, whom he had met there in 1886 but had not paid much attention to. Bernard also was in rebellion against Impressionism. He wanted to bring his painting into line with the ideas of the Symbolist poets. His aim was to work out a synthesis, with a flat, ornamental pattern of simplified forms and colors, in opposition to Impressionism, which was an analysis of natural light and atmosphere rendered in small, broken touches of scintillating color. He wanted to give the picture a spiritual significance transcending the mere evocation of nature. This intent was too close to Gauguin's own aims for the two artists not to feel mutually drawn to each other. Thus began an intense exchange of ideas in which each influenced the other. Émile Bernard seems to deserve credit for the idea of surrounding forms with a heavy outline, so as to separate the color areas and give the composition a distinct rhythmic pattern. It was Gauguin, however, who fully developed this device, which in fact he had already been trying out for some time; it appears, for example, in the pictures he painted in Martinique the year before.

In late summer of 1888 Gauguin painted *Jacob Wrestling with the Angel*, or *The Vision after the Ser-*

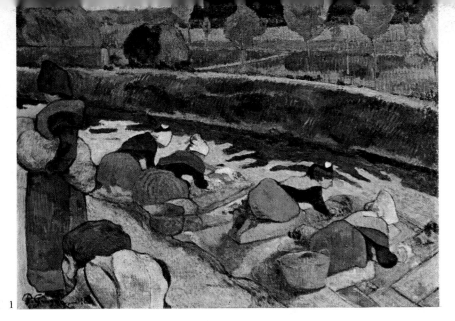

1 Washerwomen at Arles, 1888. Canvas, 28³/₄ × 36¹/₄ in. Collection of Mr. and Mrs. William S. Paley.

2 Women of Arles, 1888. Canvas, 28³/₄ × 36 in. Chicago, Courtesy of the Art Institute of Chicago, Mr. and Mrs. Lewis L. Coburn Memorial Collection.

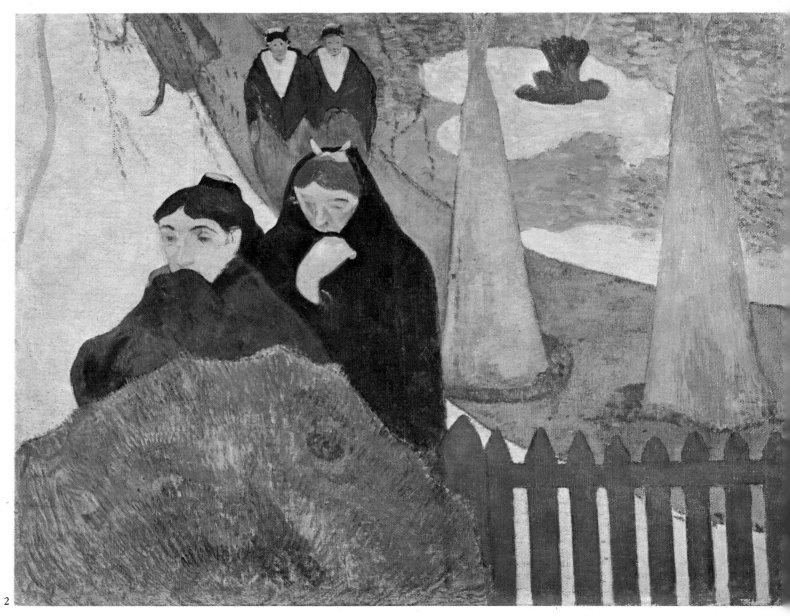

mon. In its technique and blend of fiction and reality, it exemplifies this new conception of painting and marks a further step on the path of self-expression and emancipation which Gauguin had been pursuing for years. Underlying the picture, characteristically enough, is a literary inspiration which enabled him to take liberties with nature and invent a style of his own instead of merely copying what he saw. "This year," he wrote, "I have sacrificed everything, both execution and color, in the interests of style, trying to arrive at something more than what I know how to do already."

This independent attitude to nature was not to the liking of everyone, but it found a sympathetic echo in some of the younger men. One of them was Paul Sérusier, who was spending the summer at Pont-Aven and was struck by Gauguin's innovations. When he returned to Paris, he took with him and showed to his painter friends at the Académie Julian a picture called *The Talisman* which exemplified Gauguin's ideas. Sérusier had painted it with Gauguin beside him, following Gauguin's directions. "How do you see those

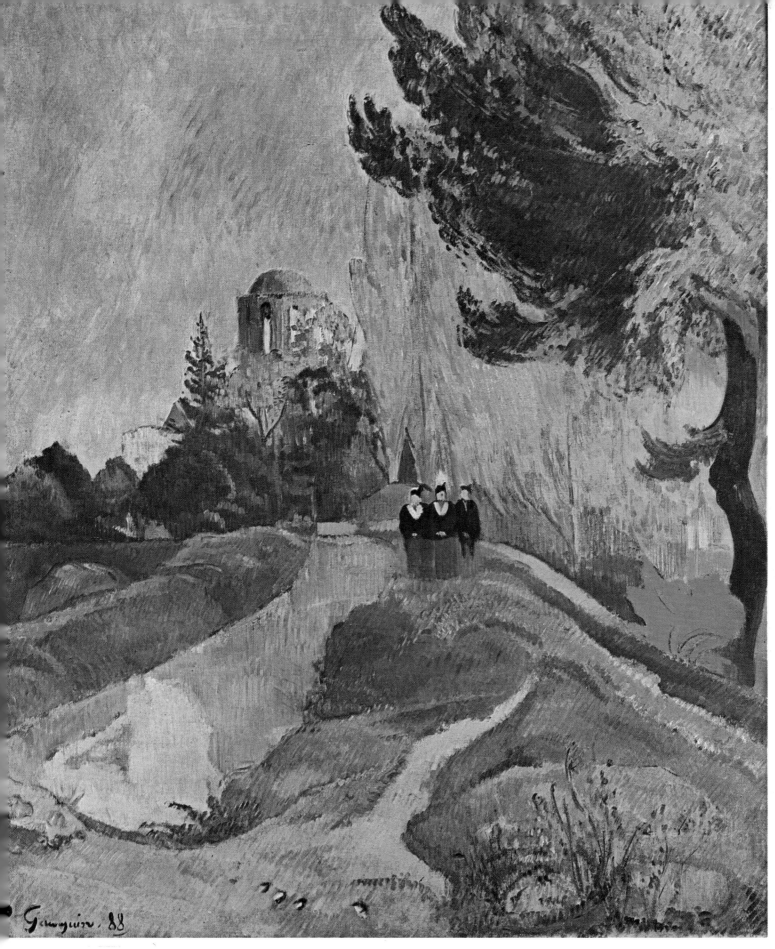

The Alyscamps in Arles, 1888. Canvas, 36¼ × 28¾ in. Paris, Musée du Louvre, Jeu de Paume.

trees?" Gauguin had said to him. "They're yellow? Then put on some yellow. That shadow is rather blue, so paint it with pure ultramarine. Those leaves are red? Put on pure vermilion."

It is clear that from now on Gauguin had rejected naturalism and began to conceive of his art as a stylized reinterpretation of visual appearances based on the emotive value of line and color. "Do not copy too much from nature," he wrote to Schuffenecker in August 1888. "Art is an abstraction. Draw it forth from nature by dreaming in front of her, and think more of creation than the end-result." Further on in the same letter he is more explicit about his intentions: "My latest work is coming along well, and I think you will find in it a special note, or rather

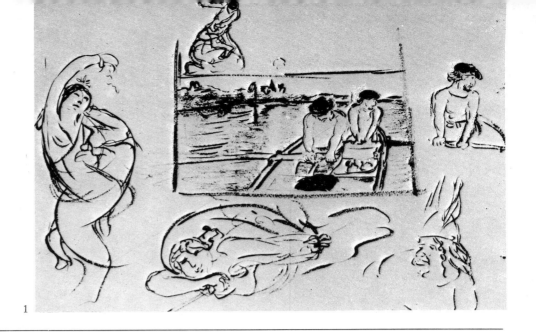

a further working out of my previous researches, a synthesis of form and color in which only the essential counts."

Gauguin had met Van Gogh in Paris in 1886, and the two men had become friends. Van Gogh had been in Arles since February 1888, and they began to write to each other. Keenly interested in his friend's ideas and work, Van Gogh invited him to come and live in Provence, in the hope that other painters might join them there and form a group of independent artists. He looked to his brother Theo, now manager of the Boussod-Valadon Gallery in Paris, to provide the financial backing for this project.

But Gauguin was in no hurry to leave Brittany. He was looked up to there as a leader and pioneer by the painters who had grouped around him. He was also detained by the fact that he had no money to pay his bill at the inn or his fare

to the south. Finally the money was supplied by Theo van Gogh, and Gauguin tore himself away, arriving in Arles on October 23, 1888. Though they esteemed and admired each other, the two men were profoundly different in temperament: Gauguin was tough, overbearing, a mixture of calculating egoism and generosity; Vincent was sentimental, impulsive, excitable. A letter from Gauguin to Émile Bernard sums up the situation: "I'm in Arles, very much out of my element, I find everything so small, the landscape and the people. Vincent and I don't often see eye to eye about anything, and still less about painting. He admires Daumier, Daubigny, Ziem, and [Théodore] Rousseau, whom I can't stand. On the other hand, he dislikes Ingres, Raphael, and Degas, whom I admire. To keep the peace I say, 'All right, Sergeant, have it your way'." And Van Gogh wrote to his brother: "Gauguin and I talk a great deal about Delacroix, Rembrandt, etc. Our discussions are *highly electric*, and we emerge from them sometimes with our heads as tired as a battery after it has been discharged."

It seems unlikely that Gauguin was so patient a peacemaker as he implies in his letters. Events were soon to show that the mounting tension between the two friends had reached the breaking point. On December 23, Vincent wrote to his brother Theo: "I believe that Gauguin is a bit disappointed in the good town of Arles, in the little yellow house where we are working, and especially in me. Indeed there

still remain for him as well as for me great difficulties that have to be overcome here. But these difficulties lie rather in ourselves than anywhere else."

That same day, a few hours later, things came to a head. "I had almost made my way across the Place Victor Hugo," wrote Gauguin in *Avant et Après*, "when I heard behind me a familiar step, quick and jerky. ... Vincent was coming at me with an open razor in his hand. The look in my eye at that moment must have been quite stern, because he stopped and, bending his head, he ran back to the house." Gauguin spent the night at a hotel. The next morning he learned that Van Gogh, on returning home, had cut off part of his left ear with the razor; then, with a towel tied around his head and wearing a beret, he went to a brothel carrying his severed ear, "cleaned and wrapped in a cloth," and gave it to one of the prostitutes, saying, "Here is something to remember me by." Notified by telegram, Theo arrived the next day and

1 A page of drawings in Paul Sérusier's sketchbook (center and right, Gauguin rowing at Le Pouldu), 1889. Paris, Boutaric Collection.

2 Gauguin painting in Schuffenecker's garden, photo of about 1889.

3 A Nightmare (drawing in Émile Bernard's sketchbook attributed to Gauguin) 1889. Paris, Musée du Louvre, Cabinet des Dessins.

4 La Belle Angèle at Le Pouldu (Portrait of Madame Angèle Satre), 1889. Canvas, 36¼ × 28¼ in. Paris, Musée du Louvre, Jeu de Paume.

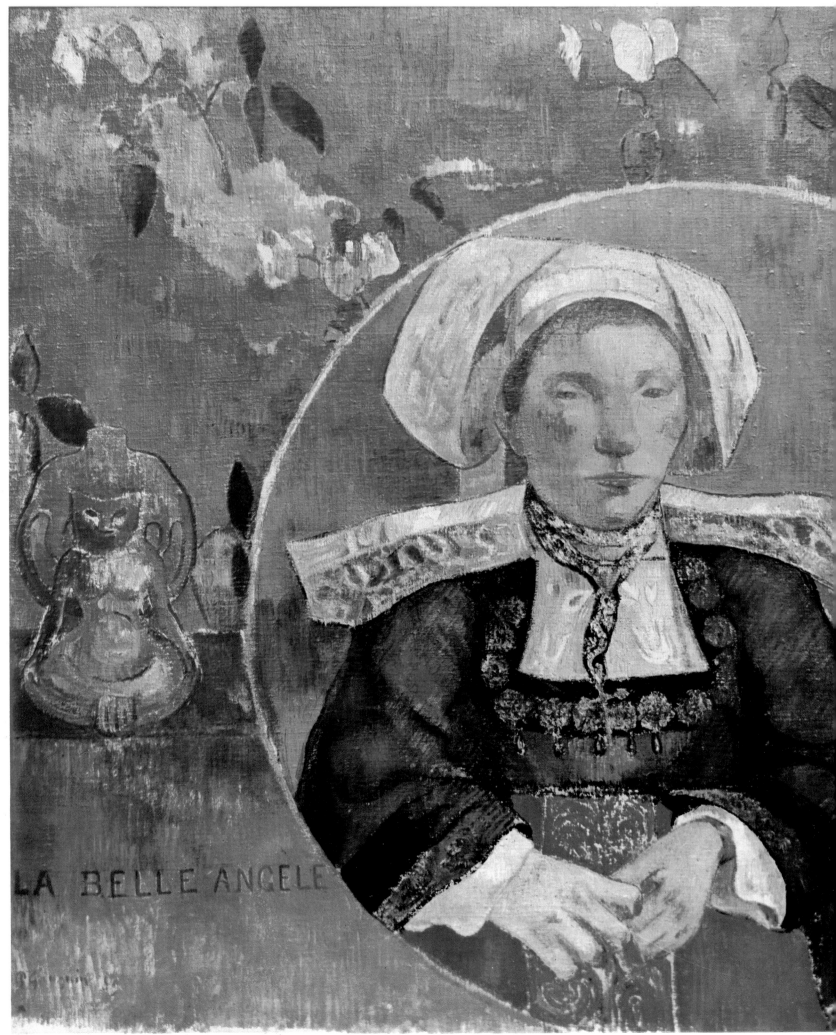

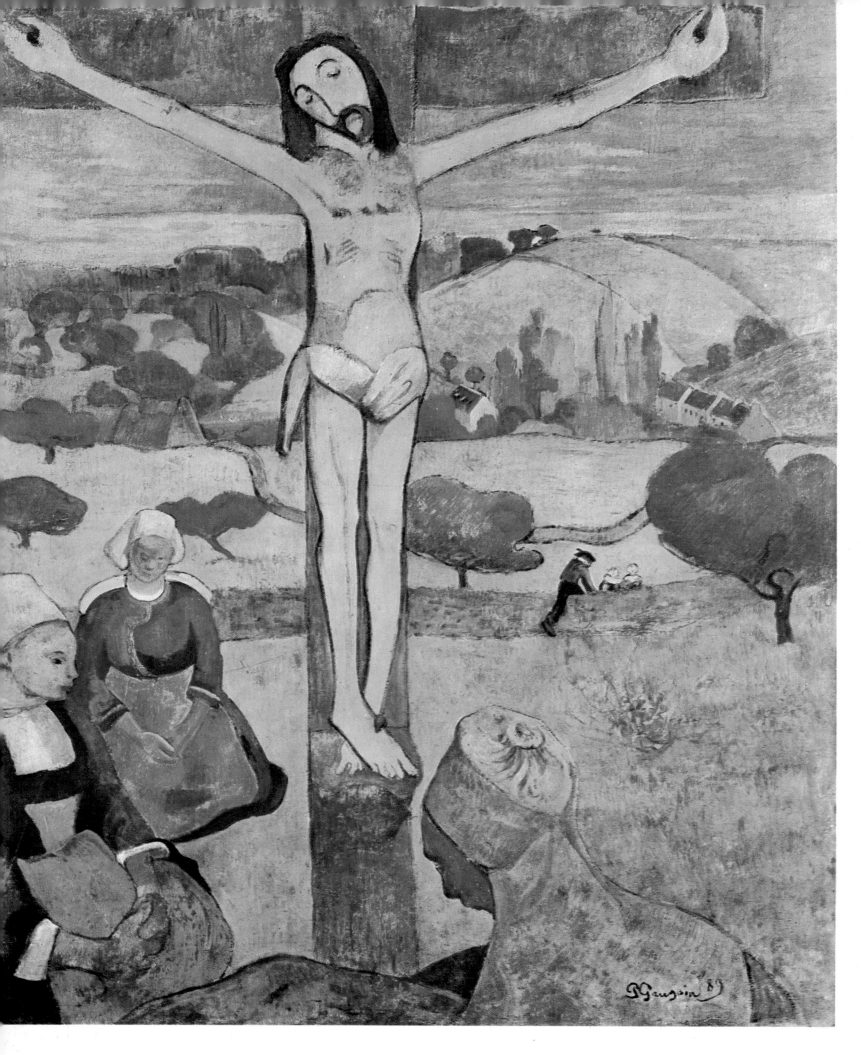

The Yellow Christ, 1889. Canvas, 36¼ × 28¼ in. Buffalo, Albright-Knox Art Gallery.

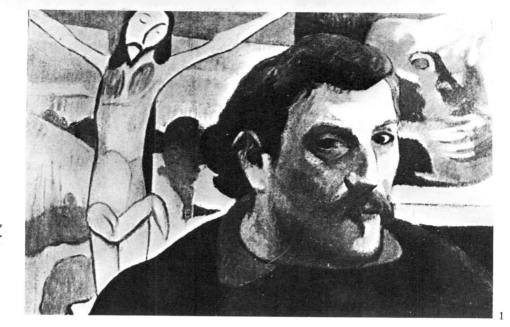

1 Self-Portrait with the
 "Yellow Christ," 1889. Canvas,
 15 × 18 in. Saint-Germain en Laye,
 Dominique Maurice-Denis Collection.

2 Crucifix in the Chapel of Trémalo
 near Pont-Aven.
 (Photo Jos Le Doaré, Chateaulin)

3 Bonjour Monsieur Gauguin, 1889.
 Canvas, 44¹/₂ × 36¹/₄ in.
 Prague, Museum of Modern Art.

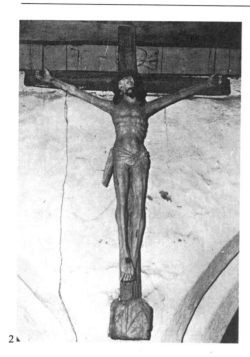

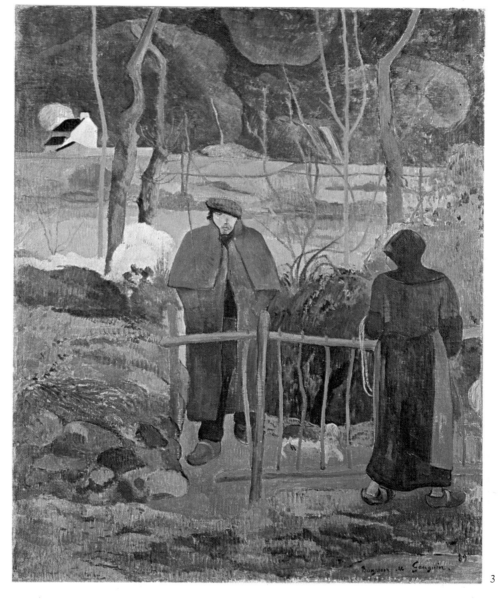

found Vincent in the hospital, well looked after.

Gauguin returned to Paris, and again Schuffenecker put him up. In April 1889 he went back to Brittany, to Pont-Aven as usual; then in June he moved to Le Pouldu, a fishing village a few miles away on the coast. Meanwhile he took part in two important exhibitions: in February with the group known as Les Vingt ("The Twenty") in Brussels, where his canvases became a subject of lively discussion; and in June with the "Impressionist and Synthetist Group," as they called themselves, in the Café Volpini on the grounds of the Paris World's Fair of 1889. The importance of the latter show was summed up a few years later by Maurice Denis: "For the first time the Synthetists and the whole Pont-Aven School, grouped around Gauguin and including Bernard, Anquetin, Laval, and Schuffenecker, exhibited their work in the Café Volpini. It may rightly be called an epoch-making demonstration. Held in a vulgar place of re-sort, this exhibition of a totally novel art marks the beginning of the re-action against Impressionism."

All the pictures painted by Gauguin in Arles (about fifteen are known) testify to this reaction. He makes systematic use of the heavy outlines surrounding forms and setting off emphatic zones of color. Light is not obtained by the flickering effect of small juxtaposed daubs of paint but, on the contrary, by use of broad areas of flat, pure, forthright colors. The pictures of 1888, especially those done in Arles from October to December, are marked by a growing stylization. This year is also the first in which, on certain canvases, we find Gauguin using the signature "P.Go," the simplification of which goes along with that artistic synthesis he was aiming at.

This development gathered momentum in the paintings of 1889. And,

1

rather unexpectedly, religious subjects came to the fore. For this trend, the 1888 composition of *Jacob Wrestling with the Angel* may be considered a prelude. Probably Gauguin had been touched by that atmosphere of popular fervor which still prevailed in these unspoiled parts of old Brittany, and was thus prompted to express this naïve mysticism in pictorial terms. A carved wooden Crucifixion in the small church of Trémalo, near Pont-Aven, inspired him to paint the canvas known as *The Yellow Christ*, in which the Saviour is nailed to a cross standing in the open fields and surrounded by kneeling Breton peasant women. The stone Calvary or wayside shrine in the neighboring village of Nizon provided the theme for another canvas, entitled *The Green Christ*. In *Christ in the Garden of Olives* Gauguin gave his own features to the suffering Christ. A depiction of his *Yellow Christ* is seen in the background of a very fine *Self-Portrait*, long owned by Marie-Jeanne Gloanec at Pont-Aven until it was purchased by Maurice Denis. To decorate the inn of Marie Henry where he stayed at Le Pouldu, Gauguin painted a peasant girl as *Joan of Arc*, with an angel flying over her head; elsewhere, on one of the doors, he painted a stylized *Self-Portrait* surmounted by a halo.

While these Brittany paintings are characterized by persistent and inventive stylization, some also show a certain irony, such as the *Self-Portrait* with a halo, the portraits of the Dutch painter Meyer de Haan, and particularly a still life of 1889 treated in the Pointillist style he occasionally used at this time. On this still life, dedicated to Marie Henry, the owner of the inn, Gauguin humorously inscribed the word "Ripipoint"—a mocking reference to the little unit dots of the Pointillist technique. As methodically devel-

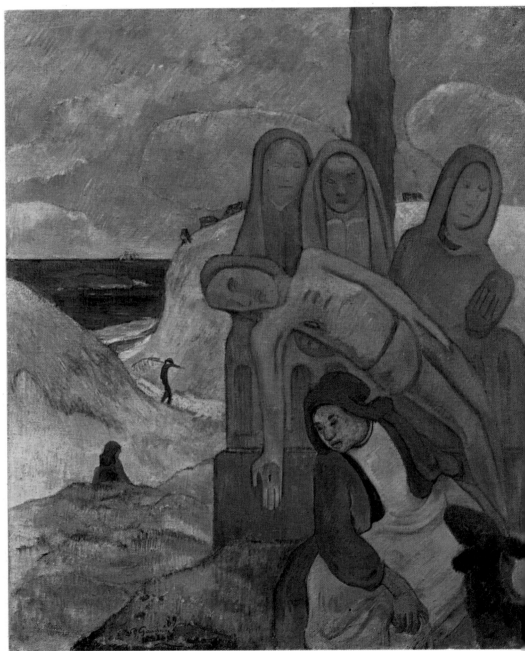
2

1 Calvary (wayside shrine) at Nizon, village near Pont-Aven. (Photo Gravier, Pont-Aven)

2 The Green Christ (Breton Calvary), 1889. Canvas, 36 1/4 × 28 3/4 in. Brussels, Musées Royaux des Beaux-Arts.

3 The Blue Roof (Farmyard at Le Pouldu), 1890. Canvas, 28 3/4 × 36 1/4 in. Collection of Mr. and Mrs. Emery Reves.

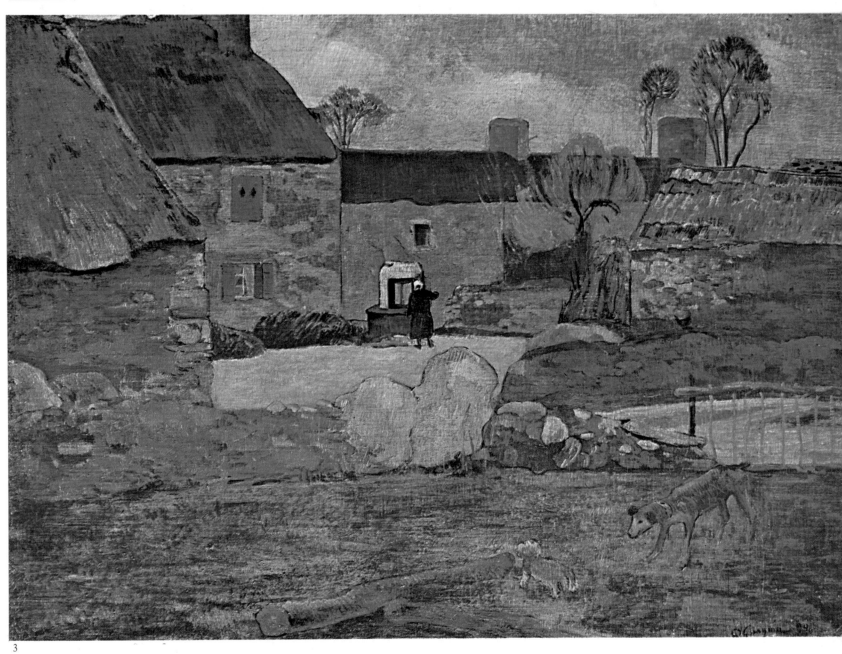

3

oped by Seurat and such followers as Paul Signac, Pointillism interested Gauguin for a short time, chiefly in the spring of 1888. He experimented with it, but used it more flexibly and less systematically than Seurat. By 1889 he seems to have given it up for good, except for an occasional parody of it.

While the figure compositions and, above all, the religious scenes provide the clearest evidence of the new trends in Gauguin's art and its spiritual content, the portraits and still lifes of the period 1888–1889 show him coming to grips more directly with purely pictorial problems and solving them with powerful original-

ity. Since his return from Martinique in 1887, Gauguin had assimilated outside influences and thoroughly transformed them, whereas earlier he had tended simply to take over the lessons of Impressionism. In the case of Pointillism, we see clearly how he made it over into something quite different, although he experi-

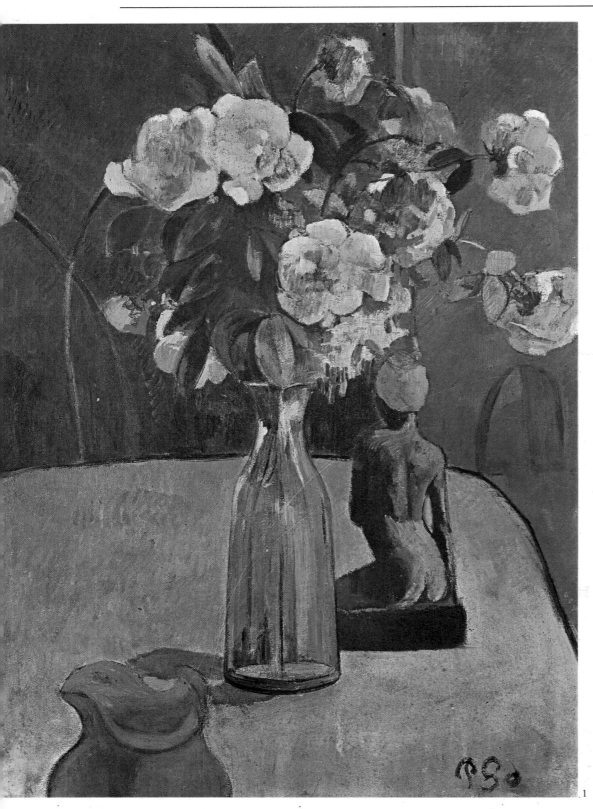

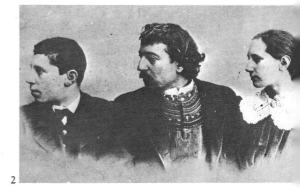

mented with it for only a short time. This creative faculty, which could afford to make no secret of its sources of inspiration, is strikingly evident in certain powerfully structured still lifes unmistakably based on Cézanne. An early admirer of the Aix master, in his fine portrait of Marie Derrien (also known as Marie Lagadu), Gauguin placed the sitter against a Cézanne still life. Several still lifes of this period represent apples. Gauguin seems to have shared Cézanne's predilection for the full and rounded form of this fruit, which provided a well-defined plastic volume, and he used it no longer as an occasional accessory but as the main theme of the picture. His landscapes gained in breadth and were better organized in accordance with an overall rhythm.

Thus, in color handling, composition, and subject matter, Gauguin now departed from Impressionism and, with growing awareness of his own powers and purposes, began to find new means of expression better suited to them. By the time he left for Tahiti in 1891, he had largely worked out and mastered these new

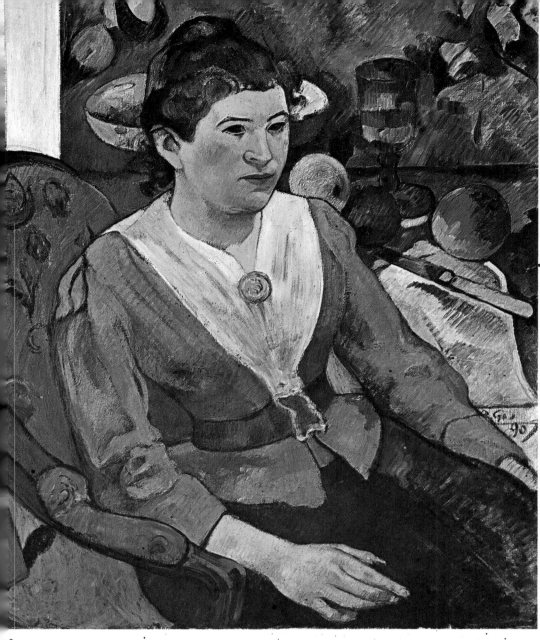

means, so that some of the last Brittany and Paris canvases, beginning with *Jacob Wrestling with the Angel*, may be considered as leading up to and prefiguring the Tahitian works—which therefore were not entirely shaped by their exotic setting.

Gauguin spent the winter of 1889–1890 in Brittany, dividing his time between Marie Henry's inn at Le Pouldu and the Pension Gloanec at Pont-Aven, and also staying for a while at Moëlan with his painter friend Meyer de Haan. In February 1890 he returned to Paris. For several months he had been thinking seriously of leaving France. He dreamed of banding together with some friends and founding a "Studio of the Tropics." He kept making plans and changing them. At first he thought of Madagascar; but from the information he obtained it did

not seem to be the ideal place, and his thoughts then turned to Tahiti. Meanwhile he again spent the summer painting in Brittany. "I am determined to leave," he wrote to Odilon Redon in the late summer of 1890, "but since I have been in Brittany my plans have changed. Madagascar is still too close to the civilized world. So I have decided on Tahiti, and I hope to end my life out there. I feel my art, which you like, is only beginning to sprout, and I hope to cultivate it there in the wild and primitive state."

He returned to Paris at the end of 1890 in order to arrange for his departure. It also gave him an opportunity to see more of his friends among the younger writers, especially the Symbolists, who admired his work. He attended their weekly gatherings at the Café Voltaire in Place de l'Odéon, and there met the

critic and writer Charles Morice, who became one of his staunchest supporters. He also met Verlaine and Mallarmé. Early in 1891 he quarreled with Schuffenecker, probably for personal reasons, as their artistic differences had been obvious for some time. He also quarreled with Émile Bernard, who resented Gauguin's growing reputation as the leader of the new Synthetist painting and felt that he was not given sufficient credit for his own contribution to it.

In order to raise the money needed to pay his fare and cover the cost of settling in the islands, Gauguin organized an auction sale of his works. It was held at the Hôtel Drouot on February 23, 1891, with the catalogue preface written by the art critic Octave Mirbeau. Thirty paintings were sold, most dating from 1888, and according to records of the sale they brought a total of 9,615 francs. When expenses had been deducted, Gauguin realized the sum of 9,130 francs. After the sale he left for Copenhagen to spend a few days with Mette and the children.

Gauguin then returned to Paris and there applied to the Ministry of Fine Arts for official backing. His efforts obtained him the right to describe himself as being entrusted with an unpaid and undefined "artistic mission." This entitled him to a preferential fare on the voyage out, and also an official letter was sent to the governor of Tahiti to smooth the way for him. On March 28 a farewell banquet was given in his honor at the Café Voltaire, presided over by Mallarmé and attended by a brilliant group of writers and painters, about forty in all, who represented the latest trends in art and literature. Then, at the beginning of April 1891, Gauguin sailed from Marseilles for Tahiti on the *Océanien*.

1 **Roses and Statuette**, 1890. Canvas, 28³/₄×21¹/₄ in. Reims, Musée des Beaux-Arts.

2 **Photograph of Gauguin with his children Émile and Aline,** taken during his brief visit to Copenhagen in 1891.

3 **Portrait of Marie Derrien with Cézanne Still Life**, 1890. Canvas, 25⁵/₈ × 21¹/₂ in. Chicago, Courtesy of The Art Institute, Joseph Winterbotham Collection.

4 - FIRST STAY IN TAHITI AND RETURN TO FRANCE

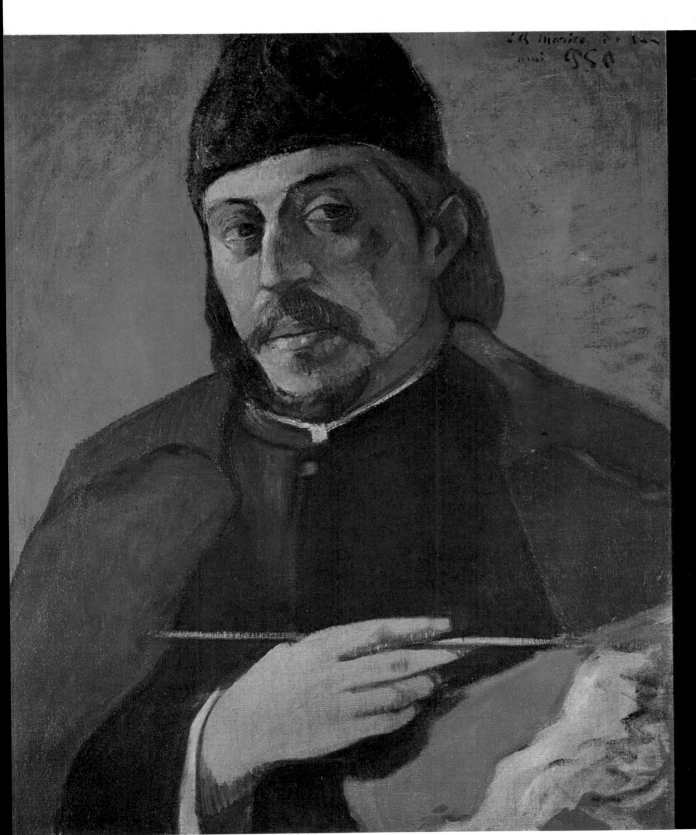

Self-Portrait with Palette,
1891. Canvas, 21⅝ × 18 in.
U.S.A., Private collection.

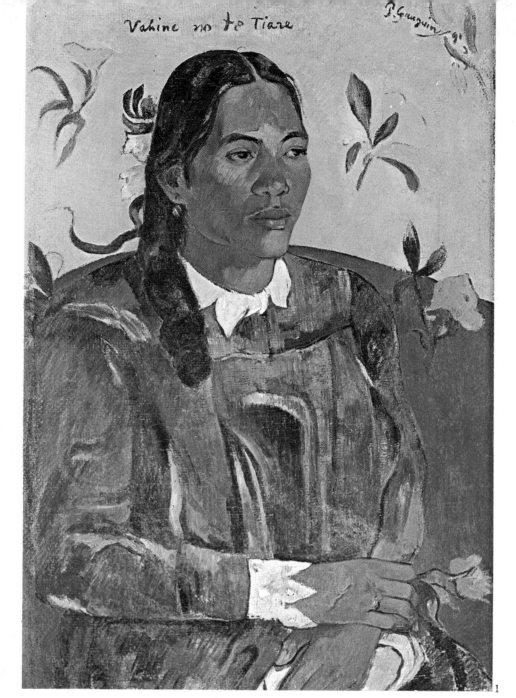

Once again Gauguin's life had come to a turning point and entered a further stage quite distinct from those through which he had already moved. Before leaving France he had wiped out the past; he had said good-by to his family, sold most of his pictures, paid his debts, and brought his friends together at a farewell banquet. His departure was not merely a flight from civilization but a commitment to a different way of life and a freer expansion of his own personality. The fact that he had been charged with a mission, however vague, gave him a certain status and made things easier for him during the voyage and on his arrival in Tahiti; it gave him a social standing quite different from that of the Bohemian life he had been leading for years.

A few years later in *Noa Noa* he described his reception in Tahiti in June 1891: "At ten o'clock in the morning I presented myself to the Governor (a Negro named Lacascade), who received me as a person of importance. I owed this honor to the mission entrusted to me—I hardly know why—by the French government." Soon after landing he wrote to Mette: "An uneventful voyage, in good health, to a wonderful place. Thanks to the article in *Figaro* and a few letters of recommendation, the ground has been well prepared. Very well received by the Governor and the Director of the Interior. ... I expect in a short time to have some well-paid portraits to do. On all sides people are inquiring whether I wish to do some. ... Tomorrow I am to see the whole royal family."

Gauguin's initial impressions were favorable, but his own appearance seems to have been rather disconcerting, both to the French officials and settlers and to the natives. A young naval officer named Jenot, who happened to be on duty when Gau-

guin landed, has left a record of his impressions: "As soon as he landed Gauguin attracted the notice of the natives, he excited surprise and was even jeered at, especially by the women. Tall, erect, and stalwart, he seemed haughty and supercilious, though his curiosity had already been aroused and he was no doubt anxious about his future work. ... What especially made him conspicuous was his long grizzled hair falling thickly over his shoulders, from under a huge brown felt hat with wide brims, like a cowboy hat. ... This was pointed out to him at once, and at first he laughed it off, but after a couple of weeks, with the help of the heat, he had his hair cut and wore it like everybody else."

The enthusiasm of the early days and the first friendly contacts did not last long, and once again his hopes were dashed by events. Pomare V, the last king of Tahiti, who had received him very cordially,

died shortly after Gauguin's arrival, and hopes of royal patronage died with him. "During the funeral ceremonies," wrote Jenot, "Gauguin kept moving about with a notebook in hand, ceaselessly jotting down sketches of attitudes and flowers." The artist realized at once that this event was a bad omen: "There have been many changes in my affairs and prospects. The King has just died, and this is a disaster for me. He had already taken a liking to me, and through him I would have had everything in my favor, money and all." In *Noa Noa* Gauguin speaks of the disillusionment that came over him in the Tahitian capital: "I was soon disgusted with life in Papeete. It was Europe all over again, just what I thought I had broken away from—made still worse here by colonial snobbery." Jenot's notes continue the story: "After a few months Gauguin decided to leave Papeete, and he went down

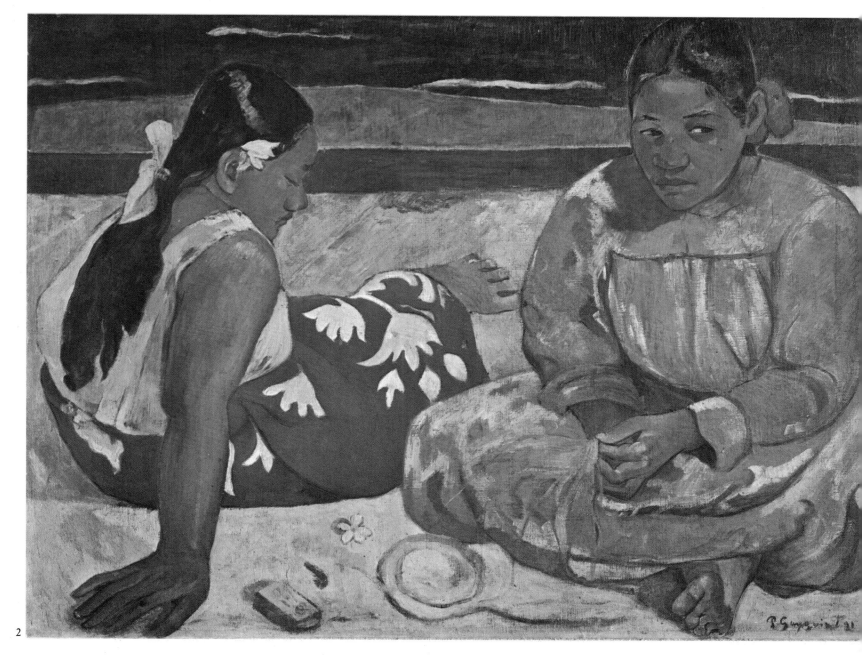

2

the coast about fifteen miles to the west and settled by the sea at Pacca. Then, after a few months, he moved a little farther to Mataiea, a quiet spot with only natives around him, where he could give all his time to thinking, meditating, and working." In October, with the approval and cooperation of the villagers, a native girl came to share his hut: Teha' amana, whom in his book of reminiscences entitled *Noa Noa* he calls Tehura.

This idyllic existence did not last long. His small capital was soon exhausted and no remittances arrived from France, in spite of the promises made by his friends and picture dealers. He fell ill and spent some time in the hospital. Discouraged by bad health and money worries, in March 1892 Gauguin decided to return to France. While going to Papeete to apply for re-

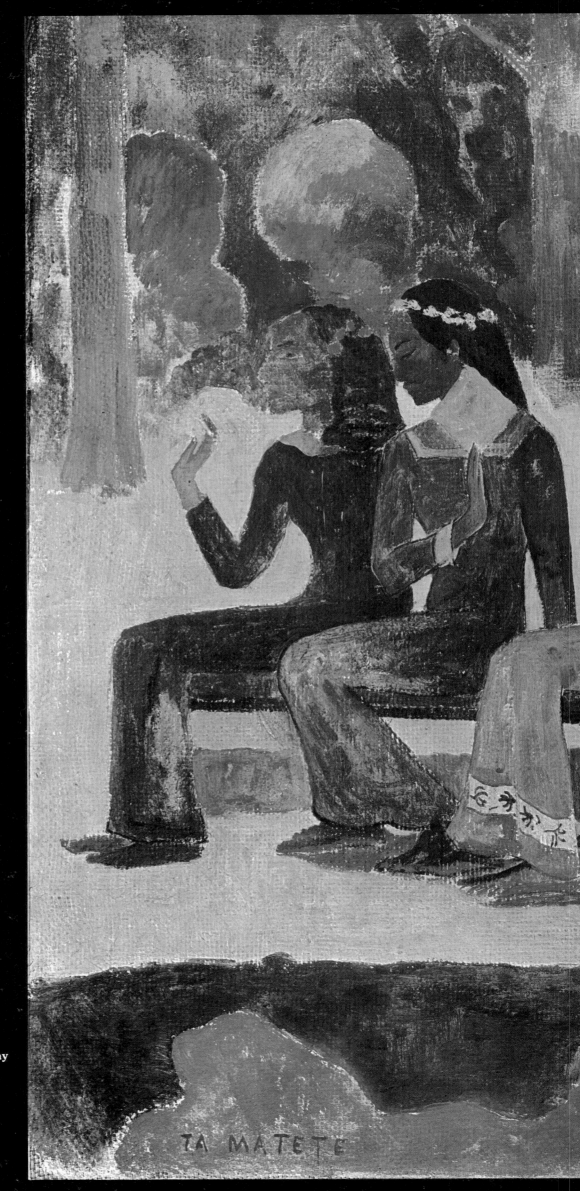

We Shall Not Go to Market Today
("Ta Matete"), 1892.
Canvas, 28³/₄ × 36¹/₄ in.
Basel, Kunstmuseum.

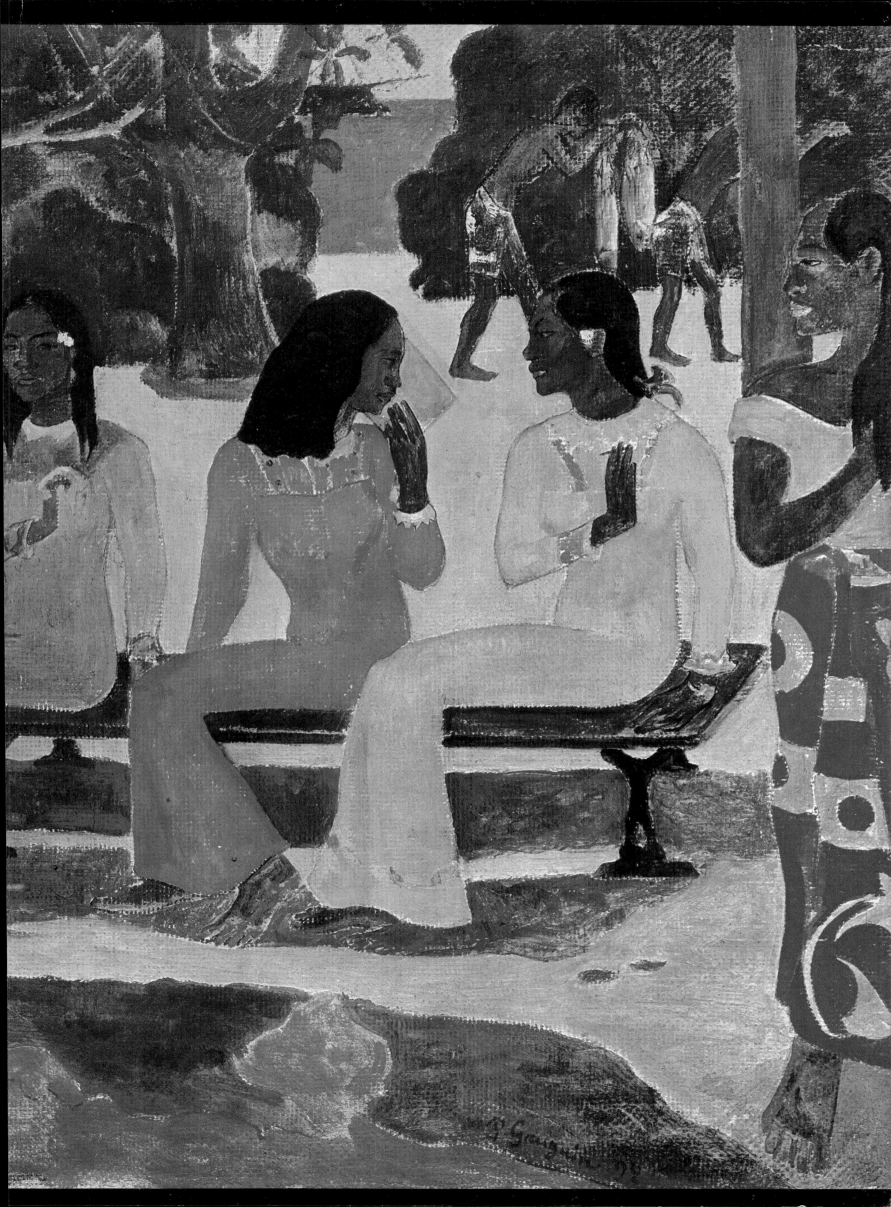

1

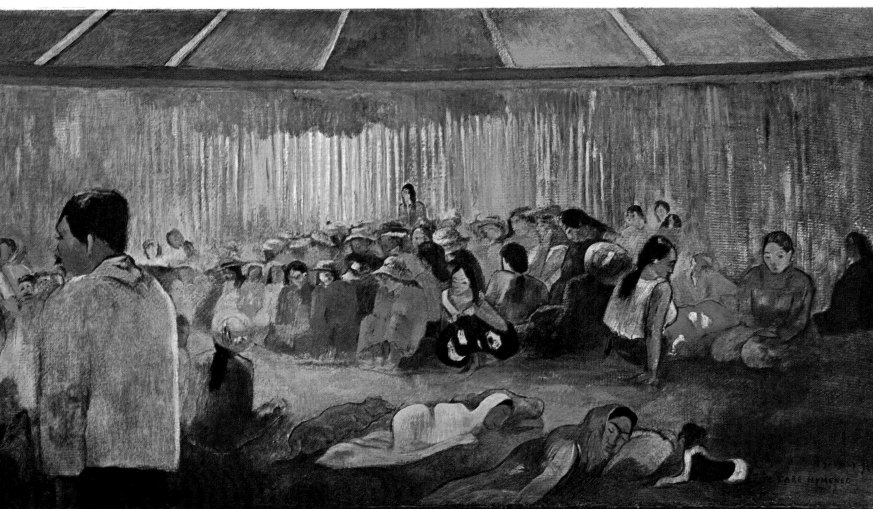

2

patriation, he met the captain of a trading schooner who, when he told him his troubles, gave him 400 francs for a picture and commissioned him to paint a portrait of his wife. At once his hopes were rekindled, and he dropped the idea of leaving Tahiti. But by June he was again in financial straits and, seeing no way out, applied officially for repatriation.

He had worked hard in Tahiti and expected to be able to take home about fifty canvases. His work now seemed to be better appreciated in Denmark, for he learned from his wife that she had found buyers for the pictures he had sent back. Even so, no money reached him for some months to come, and he scraped along on what he got from an occasional sale locally. "I'm trying desperately to keep afloat. I did two wood carvings not long ago which I managed to sell for 300 francs, and so I'll stay on for another three months. ... For the last month I've been out of canvas and can't afford to buy any."

One of the few friends to stand by him and write to him at this time was the painter Daniel de Monfreid, from whom Gauguin received not only moral support but also financial help. "I have received the 300 francs remitted by you ... and just as I was about to try and come home. I'm at the end of my tether and worn out. ... For the time being, with these 300 francs, I can hold my own. ... To meet my commitments and hold on, I've stopped eating, just a bit of bread and tea. So I have lost a lot of weight, weakened myself, and wrecked my stomach."

He learned with dismay that none of the money from the sale of his

1 Sketch for the "House of Song," c. 1892.
Pencil, 7⁷/₈ × 12¹/₈ in. Private collection.
2 The House of Song ("Te Fare Hymenee"), 1892. Canvas, 20 × 35¹/₂ in.
Dallas, Collection of Mr. and Mrs. Algur H. Meadows.
3 Annah the Javanese, 1893. Canvas, 45⁵/₈ × 31⁷/₈ in.
Bern, Private collection.

pictures in Europe had been sent to Tahiti. He received a letter from Maurice Joyant, Theo van Gogh's successor as manager of Boussod-Valadon: "Joyant tells me that the outlook has changed considerably, and my reputation is on the rise. He gives me, too, a statement of account, from which I see that 853 francs were paid over to Morice for me on May 23, 1891 (nearly two years ago), which means that Morice has done me out of 1,353 francs that would have saved my life. ... My wife has also sold 850 francs' worth of pictures, but she needs the money and apologizes for not being able to send me any." Finally, in March 1893, the Ministry of the Interior agreed to "bear the expenses of repatriating Monsieur Gauguin, artist-painter, in distress in Tahiti," and on June 14 he sailed on board the *Duchaffault*. He left the islands regretfully, for it had been a rewarding experience.

"I left," he wrote in *Noa Noa*, "two years older, and twenty years younger, *more of a barbarian too* than when I came and yet more schooled. Yes, the savages have given many lessons to the old civilized man, many lessons from these ignorant people in the science of life and the art of being happy. ... When I left the dock and boarded the ship, I looked back for the last time at Tehura. She had been crying for several nights! Weary now and still sad, but quiet, she was sitting on the stone pier, with her legs hanging down, just touching the salt water with her broad, sturdy feet. The flower she had been wearing behind her ear had fallen into her lap and wilted."

After waiting twenty-five days in Nouméa for another ship, Gauguin boarded the *Armand-Béhic* and landed in Marseilles on August 30, 1893, almost penniless: "I have just

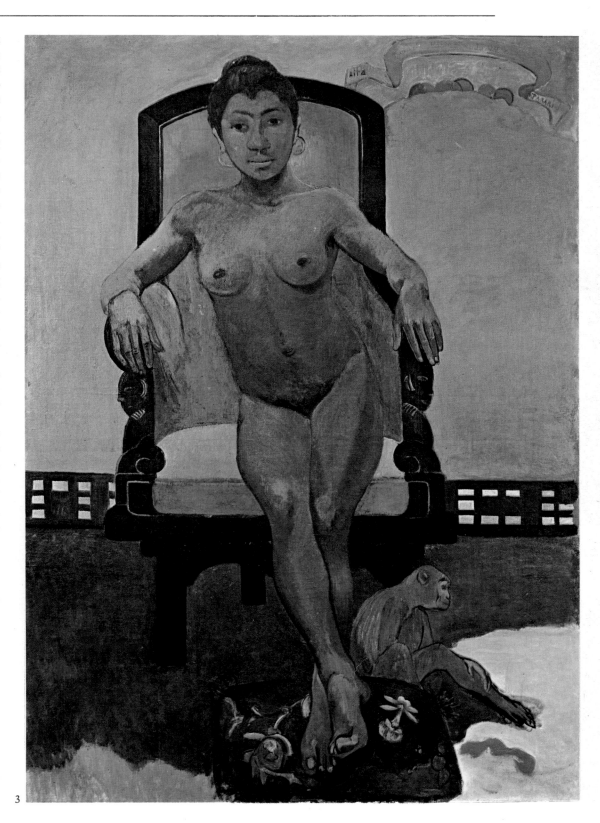

3

1 Paul Sérusier and friends with Annah the Javanese,
 in Gauguin's Paris studio in 1894.
2 The Tahitian Goddess Oviri, 1893–1895. Terracotta. Private collection.
3 The Siesta, 1894. Canvas, 35 × 45³/₄ in. Collection of Mrs. Enid A. Haupt.

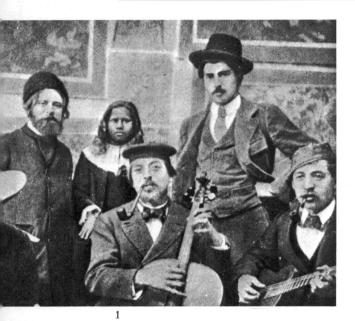

1

enough left to send a telegram and take a cab with my bags to a hotel where I'll wait for the funds," he wrote to his wife. And to Daniel de Monfreid: "I have landed today, Wednesday, at twelve noon, with four francs in my pocket!"

Luckily for him, his friends Sérusier and De Monfreid had foreseen this situation and sent him a remittance of 250 francs. So on September 1, 1893, he arrived back in Paris, where he rented a room for three months at 8 Rue de la Grande Chaumière. One of the first things he did was to call on Paul Durand-Ruel, the picture dealer who had played so important and courageous a part in backing the Impressionists and popularizing their work. Degas put in a good word for him, and Durand-Ruel agreed to an exhibition at his gallery in Rue Laffitte, which was held in November of that same year, 1893.

Meanwhile his uncle Isidore, with whom he had lived as a child in Orléans, died and left him about 9,000 francs. This set him back on his feet for a while and enabled him

to meet certain expenses entailed in organizing his exhibition, which comprised thirty-eight canvases from Tahiti, six from Brittany, and two sculptures. The catalogue had preface by Charles Morice, who pointed out the novelty and originality of the Tahitian paintings. But, on the whole, both critics and public were bewildered by their simplified design and vivid colors. Although the exhibition was not a financial success, it did put Gauguin in the public eye once more and aroused discussion and curiosity. Even his enemies recognized that here was an original personality to be reckoned with.

With money in his pocket and the satisfaction of finding himself a center of interest, Gauguin now deliberately cultivated the flamboyant and eccentric side of his personality. Taking a studio in Montparnasse at 6 Rue Vercingétorix, he painted the walls chrome yellow and adorned them with his Tahitian paintings and an array of objects and weapons from the South Seas. "It was all in good fun," wrote Charles Morice, "and barbaric and strange. On the painted glass of the window the master wrote *Te Faruru* ('lovemaking here')." He dressed fantastically: "He wore a long, blue, close-fitting cloak with mother-of-pearl buttons. Underneath was a blue waistcoat buttoning down one side, with a trimming of green-and-yellow embroidery around the neck. His trousers were putty-colored. On his head he wore a gray felt hat with a sky-blue ribbon. His hands, sinewy rather than elegant, were covered with immaculate white gloves. For a cane, he carried a stick decorated by himself with barbaric carving and with a real pearl set in the wood." Morice then describes the evening parties, when Gauguin held open house for friends in his new studio:

"These simple and cordial gatherings took place in a youthful, almost boyish atmosphere, and some of the best poets and artists of the day could be seen there—the composer William Molard, the sculptors Francisco Durrio and Aristide Maillol, the poets Paul Roinard and Julien Leclercq, the painters Armand Séguin, O'Connor, Zuloaga, Daniel de Monfreid, Chamaillard, and Maufra, and Strindberg." Gauguin lived there with a mulatto woman known as Annah the Javanese, thus described by his biographer Jean de Rotonchamp: "Tinkling a primitive bell at the door, the caller was met by a superb mulatto with glowing eyes. Gauguin had picked her up in Paris,

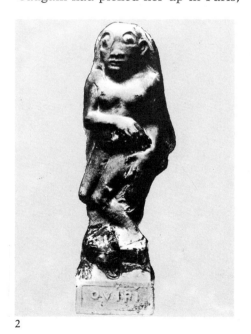

2

but she came from Java. A shivering monkey crouched among the easels. ... The exotic décor suggested the *pied-à-terre* of a naval officer or an explorer's transient home."

After spending the winter in Paris, Gauguin went to Brittany again in the spring of 1894, to both Pont-Aven and Le Pouldu, where he met the Polish painter Wladyslaw Sle-

58

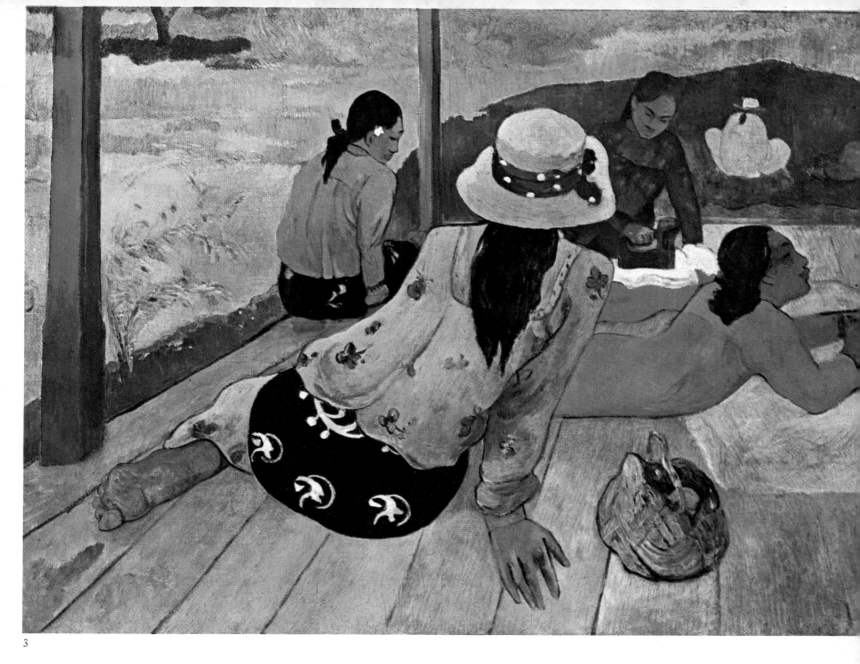

3

winski. Around him gathered a group of disciples: Moret, Séguin, Chamaillard, Sérusier, Filiger, O'Connor, and Jourdan.

On May 25, 1894, at Concarneau, Gauguin got into a brawl when some Breton sailors made fun of his companion Annah the Javanese, whom he had brought with him from Paris, together with her monkey. "They pelted us with stones," said Gauguin. "With two punches I knocked down a pilot who attacked me. Then he went and fetched the crew of his boat, and fifteen men set upon me. I fought back and held my ground. But when I caught my foot in a hole, I tripped and broke my leg. They kicked me with their wooden shoes as I lay on the ground, until I was finally extricated. I had to be taken to Pont-Aven, where I'm recovering. ... My ankle is broken, and the shattered bone was driven through the skin." He brought an action for assault against the sailors, and in August was awarded 600 francs' damages. "I have spent 475 francs on the doctor and 100 francs on the lawyer, besides all my hos-

pital expenses. Which means that I'm completely ruined." While he was laid up in Brittany, Annah deserted him and returned to Paris; she ransacked his studio in Rue Vercingétorix and disappeared.

Gauguin felt that his luck had run out in France, and again his thoughts turned to the South Seas. "I have made up my mind to go back to Oceania for good. I shall return to Paris in December with the sole purpose of selling off all my effects for whatever price I can get for them (everything). If I succeed, I'll leave in February." By the end of December 1894 he was back in Paris, and Charles Morice and a few other friends offered a small banquet in his honor at the Café des Variétés. At the same time he organized a private exhibition of his work in his studio, chiefly drawings, along with a few carvings and prints.

To raise funds for his departure, Gauguin arranged for a public sale at the Hôtel Drouot auction rooms. It took place on February 18, 1895. The catalogue, prefaced by a long letter from the great Swedish writer

Strindberg, listed forty-five paintings, mostly done in Tahiti, and twenty-five drawings. In his preface Strindberg explained clearly what it was in Gauguin's art that made it unacceptable to most of his contemporaries and yet at the same time very appealing to others, who had learned to appreciate it for its own sake. These admirers were still very few, and the sale was a failure. It raised only 2,986 francs, and Gauguin was forced to buy back many of the pictures himself. According to a letter to his wife, he made no profit at all and was even left with a deficit of some 465 francs after commissions and expenses had been deducted.

On July 3, 1895, Gauguin sailed for Tahiti for the second time, embarking at Marseilles on the *Australien*. After changing ships in Sydney and again in Auckland, New Zealand, he arrived in Papeete on September 8 aboard the *Richmond*. Just before leaving France, he had said to Charles Morice: "It remains for me to carve my tomb out there in the silence and among the flowers."

5 - THE SECOND STAY IN TAHITI

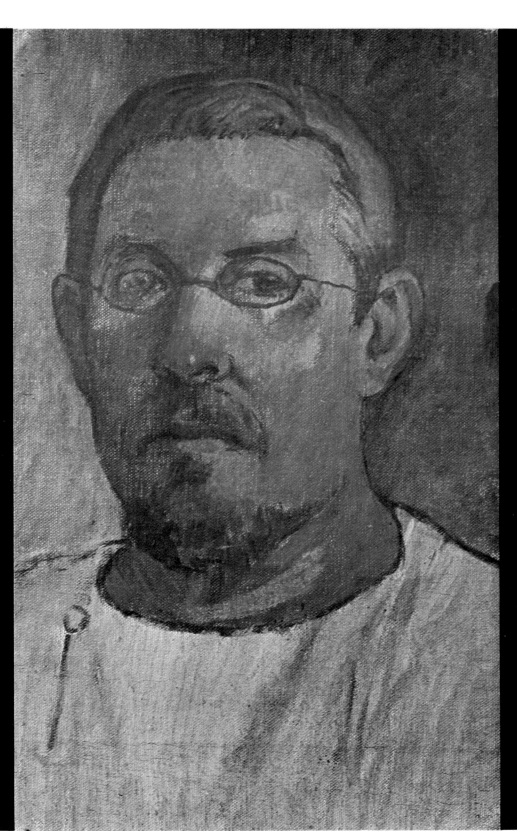

Final Self-Portrait, 1903.
Canvas mounted on wood,
16¹/₂ × 9³/₄ in.
Basel, Kunstmuseum.
(Photo H. Hinz-Ziolo)

1 Whence Do We Come? What Are We? Where Are We Going?, 1897.
Canvas, 54³/₄ × 147¹/₂ in. Boston, Courtesy of Museum of Fine Arts,
Tompkins Collection.

2 Whence Do We Come? What Are We? Where Are We Going? Pen and watercolor,
in a letter of February 1898 to Daniel de Monfreid.

3 Sketch for seated figure on the right of Whence Do We Come?, 1898.
Pencil, 5 × 5¹/₂ in. Paris, Lebel Collection.

After staying a few weeks in Papeete, the capital, Gauguin went to Punoauia, a village on the western coast of Tahiti. "Imagine a large sparrow cage made of bamboo and divided in two by my old studio curtains, the roof thatched with coconut leaves. One half is the bedroom, with very little light, so as to keep it cool. The other half, with a large window, does duty as a studio. On the floor are mats and my old Persian carpet. The whole place is decorated with fabrics, curios, and drawings." Again he had cut himself off from the past, and, except for Daniel de Monfreid, the friends he had left behind seldom wrote to him. Money he had lent in France was not repaid, and the dealers who had promised to sell his work let him down.

The following year, 1896, things grew steadily worse. The gulf between him and his wife grew wider, and their mutual recriminations more bitter. His health gave way, and he was constantly short of money. In April he wrote: "Ever since I got here, my health has been deteriorating every day. My broken foot makes me suffer terribly. I have two open sores which the doctor has failed to heal—in the tropics it's difficult. At night the violent throbbing keeps me awake till midnight. ... I have just borrowed 500 francs to eat with for a few months. With the 500 francs I owe on my house, this brings my debts to a thousand francs. And I am not being unreasonable. I manage with a hundred francs a month for myself and my native wife."

In July 1896 he had to go to the hospital and was under treatment for a month. "Thank God I no longer suffer, though I am only half cured. But I am very weak, and to set myself right again I have nothing to drink but water and for food a

1

bit of rice cooked in water." Even so, he kept up his spirits, and early in January of 1897 his hopes revived: "I have received 1,200 francs this month and expect another 1,600 francs shortly. So I have paid off my debts here. This will keep me going for six or eight months." But in March he received crushing news from his wife: his twenty-year-old daughter Aline, his favorite child, had died in Copenhagen, carried off in the space of a few days by pneumonia. "I have lost my daughter," he wrote, "I love God no longer. ... Her grave is here close by me, and my tears are living flowers."

There was further trouble: his landlord died, and the new owner of the land forced him to pull down his hut and move. He had to rebuild his hut elsewhere. "Besides a considerable loss of time, I reckon this

is going to cost me from 700 to 1,000 francs. It's enough to drive you crazy." He secured a year's loan of 1,000 francs from the Caisse Agricole of the Bank of Tahiti, but this was soon swallowed up by the cost of rebuilding and refitting his hut. More ominously, his eyes were giving him trouble. "I have double conjunctivitis, which has been treated with copper sulphate for two months," he wrote in June. "I haven't a penny left. I have exhausted all my credit and don't know what is to become of me." Then in July: "I don't know what will become of me. ... I have fainting fits and attacks of fever. My feet are so painful I am forced to lie on the bed or sit in a chair. My mind is gone, my work is gone, and no hope left." In August: "I don't have a single penny, and not even the Chinaman

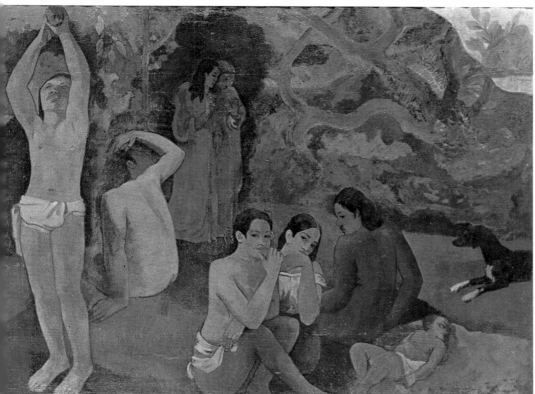

tempt, Gauguin painted the largest picture he ever undertook, over twelve feet long and four and a half feet high. "Before dying I wanted to paint a large canvas which I had in mind, and during the whole month [December 1897] I worked on it day and night at a feverish pace. ... I put into it, before dying, all my energy, so much painful passion in terrible circumstances and so sharp a vision without any alterations that the motif disappears and life wells up from it." This painting, which he called *Whence Do We Come? What Are We? Where Are We Going?*, was at once the out-

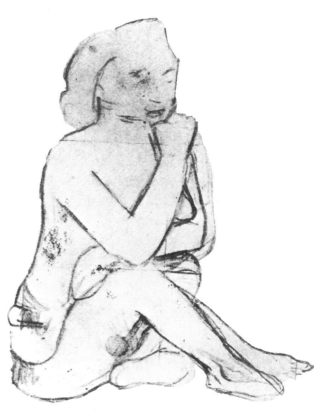

will give me any more bread on credit." In September: "My head is as empty as my stomach, with nothing clear ahead of me and no hope left. What shall I do? I can see no way out except Death, which delivers us from everything."

In November 1897: "God at last has heard my voice imploring not a change, but complete deliverance. My heart, severely tried by repeated shocks, has become very much affected. I have fits of suffocation and vomit blood every day. My carcass is still resisting, but it's bound to crack, which after all is better than killing myself outright, which I would soon be driven to do for lack of food and no means of getting any." And again: "I only want Silence, Silence, and again Silence. May I be left to die in peace, *forgotten*, or if I must live, may I be left still more in peace and forgot-

ten." In December: "My health gets worse and worse, and to regain my strength I haven't even got a crust of bread, not to speak of peace and quiet. I live on a little water and a few guavas and mangos which are growing just now, and occasionally some shrimp whenever my wahine manages to catch a few."

At the end of the year, destitute and in utter despair, he was driven to a suicide attempt. "I wanted to kill myself. I went up to a remote spot in the mountains where my corpse would be devoured by ants. I had no revolver, but I had some arsenic which I saved up when I was sick with eczema. Was the dose too strong, or was it the vomiting that prevented the poison from taking effect by throwing it up? I don't know. Anyhow, after a night of terrible suffering, I got home again." Just before this abortive suicide at-

come and summing up of Gauguin's philosophy and stylistic researches. He meant it as his spiritual and artistic testament, since he intended to end his life after finishing it. But his suicide attempt miscarried,

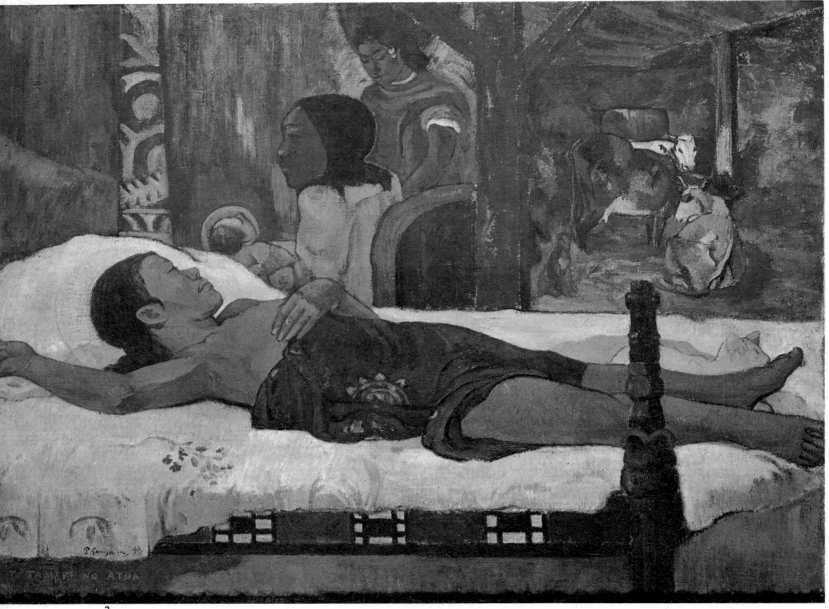

2

and life went on as before, in dejection and gnawing uncertainty. In February 1898 he wrote: "I have just received 700 francs from Chaudet and 150 francs from Maufra. With this I can pay my most demanding creditors and keep on living as before in misery and shame, until the month of May when the bank will dispossess me and sell off at any price everything I own, including my pictures. Well, when that time comes, we'll see about making a fresh start in another way." That was the important thing: to make a fresh start in another way. Once again a cycle of his life had come to an end, and the past was written off.

Two works of this period bear witness to the change. In this same year, 1898, Gauguin painted another composition of the same proportions as *Whence Do We Come? What Are We? Where Are We Going?*, but not so large. This may, however, have been intended as a study for a larger composition. The new painting contrasts in every way with the prior one. First, in its theme. Its title,

1 **Studies of Body and Limbs, c. 1896.**
Pencil, 10¹/₄ × 6¹/₂ in. Private collection.

2 **The Birth of Christ, Son of God ("Te Tamari No Atua"), 1896.**
Canvas, 37³/₄ × 50³/₈ in. Munich, Bayerische Staatsgemäldesammlungen.

3 **Tahitian Pastoral ("Faa Iheihe"), 1898. Canvas, 21¹/₄ × 66¹/₂ in.**
London, Tate Gallery. (Photo Zauho-Press-Ziolo)

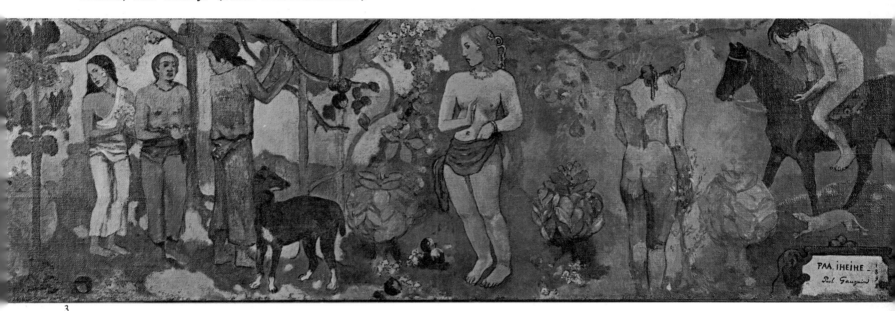

3

Faa Iheihe, may be translated as "Pastoral with Preparations for a Festival." Its mood is one of restful serenity and communion with nature, whereas *Whence Do We Come?* represents an inscrutable, self-contained world. Second, in the organization of the composition. All the elements in *Whence Do We Come?*, both figures and plants, are made up of broken or coiling lines; those in *Faa Iheihe* rise up vertically, without any descending lines. Third, in coloring. The palette of *Whence Do We Come?* consists chiefly of darker tones, blues and greens, while for *Faa Iheihe* Gauguin chose such luminous colors as ochers and pinks. Lastly, it should be pointed out that all the figures in *Whence Do We Come?* were taken over from pictures which Gauguin had executed in the preceding years. Some elements (the crouching woman on the far left, the cat in the center), in fact, can be traced back to pictures he painted in Brittany in 1888 or 1889. But nothing in this great composition was carried over into his later work, except in a painting of early 1898 (done, that is, in the year

immediately following *Whence Do We Come?* and so still under its direct influence) and in another of 1903, the year of the artist's death. Of *Faa Iheihe*, however, the opposite is true: nothing in the picture derives from work done before 1898 (except for the *Pastoral* of 1896 in the Musée des Beaux-Arts of Lyons), but all the figures in it were taken up and re-used in later canvases.

Thus, if *Whence Do We Come?* may be considered to conclude and sum up all that Gauguin had done before, *Faa Iheihe* marks a renewal and a fresh start, containing in outline what was to come. The contrast between the two pictures is all the more significant in view of the emphasis which Gauguin consistently laid on symbolism both in theory and in practice, in the expression of feelings through the emotive power of lines and colors.

As if fate were inclined to facilitate this artistic renewal, his material situation improved. In August 1898, he accepted an office job with the French authorities in Papeete. He did so reluctantly, and the wages were low, but at least it gave him

a regular income. "I have obtained a job as clerk and draftsman at a salary of six francs a day." In May, when his debt fell due, the bank gave him a respite of five months. By August, thanks to his earnings and a few remittances from France, he was in the clear again. "So now at last I've wiped out all the debts I had here. If I can just stick to my little job, the day of deliverance will come when I can take up my brushes again, but I will only do so when I have saved up a little money." In October his thoughts turned to planting flowers, and he wrote to Daniel de Monfreid: "If you happen to sell anything for me, I would like you to send me some shoots and seeds of flowers that will grow in the tropics. I want to embellish my little plantation."

In Paris the dealer Ambroise Vollard was taking an interest in Gauguin, who had sent him several consignments of pictures. By the beginning of 1899, thanks to funds sent him by De Monfreid, he was able to give up his job in Papeete and return to his hut at Punoauia. But there was no relief from the fester-

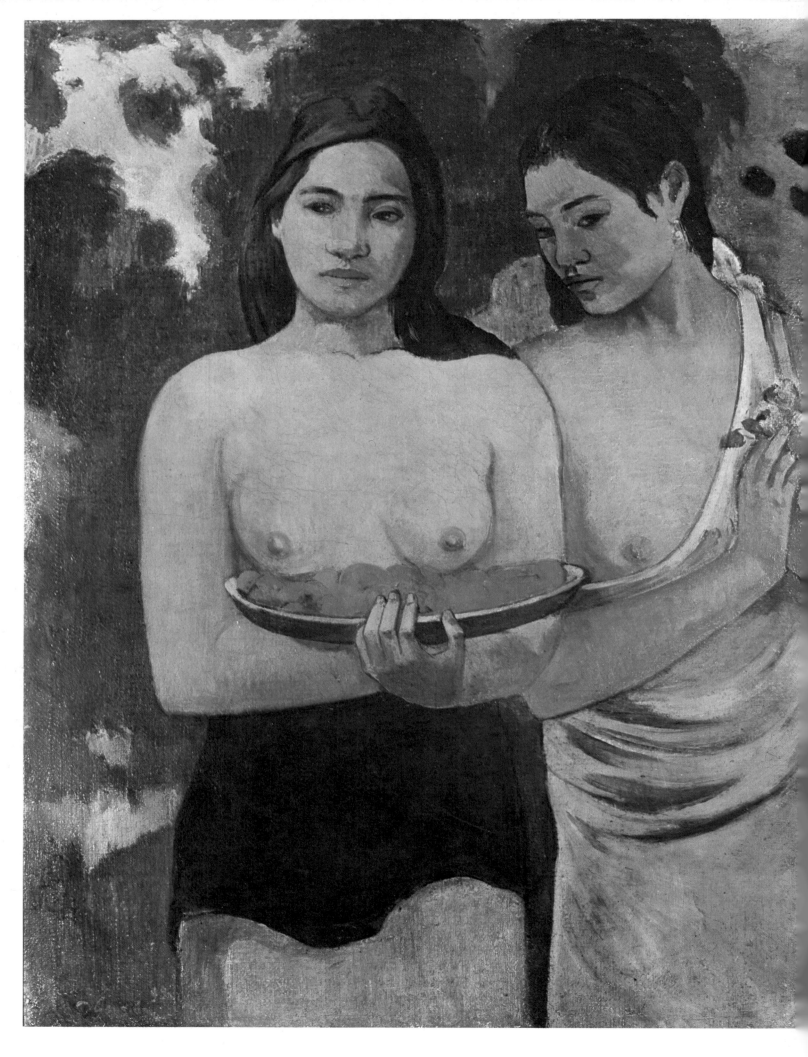

Two Tahitian Women ("Les Seins aux Fleurs Rouges"), 1899.
Canvas, 37 × 28¹/₂ in. New York, The Metropolitan Museum of Art,
Gift of William Church Osborn, 1949.

1 Head of a Tahitian Girl, c. 1899.
Charcoal, 14⅛ × 11 in.
Geneva, Collection of Jean-François Dumur.

2 The Flight (or The Ford), 1901.
Canvas, 28¾ × 36¼ in.
Moscow, Pushkin Museum.

ing sores on his leg; the proceeds from sales made by Vollard did not come up to his expectations; and his hut and belongings had suffered while he was away. "I have found my hut in deplorable condition. Rats have destroyed the roof and so a lot of things have been ruined by the rain. A whole set of very useful drawings was destroyed by cockroaches, and a large unfinished canvas also destroyed by these filthy insects." His worries were not at an end, but he hoped to take his mind off them by getting back to work. "I have just a hundred francs in cash to live through the month of May. Later, if my ailments give me a moment's respite, I'll try despite my troubles to do a dozen or so good canvases."

But he was increasingly resentful of the petty annoyances of colonial life and what he felt to be the corrupting influence of the missionaries and French officials. His resentments were sharpened, too, by broken health and his failure to achieve that ideal life for which he yearned, which always seemed just out of reach. His irritation and defiant temperament incited him to take up arms against what appeared to him the unnecessary obstacles interfering with a happy, carefree existence in the islands. He wrote several articles sharply critical of the colonial administration, pointing out its abuses and mistakes; these were published in a short-lived antigovernment newspaper called *Les Guêpes* ("The Wasps") which had been started in Papeete. A little later, in August 1899, in order to express his feelings more freely, he launched a satirical broadsheet of his own, called *Le Sourire* ("The Smile"), which he wrote and illustrated entirely by himself and ran off on a stenciling machine. "Unfortunately it is passed on from hand to hand,

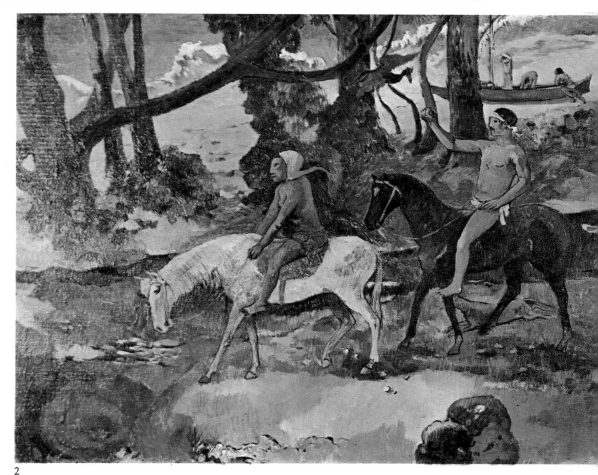

2

and so I never sell very many. In spite of that, for some time I have managed to make about fifty francs a month out of it, which has helped me keep afloat and not get too much into debt."

Little by little, with the loyal help of Daniel de Monfreid, and in spite of setbacks, misunderstandings, and broken promises, his connections with dealers and collectors in France were becoming firmer and more regular in character. Vollard was soon to offer him a contract with a fixed price per canvas. A new collector, Prince Emmanuel Bibesco, showed keen interest in his work, and he found another enthusiastic supporter in a collector from Béziers, Gus-

tave Fayet, whom De Monfreid told him about: "He is a man who appreciates your two canvases at their true artistic value. They fit into his collection admirably between a magnificent Cézanne and a Degas. He tells me that nothing around them can stand up to your pictures."

But Gauguin was plagued by ill health. "The pain is too much for me, and I cannot get down to work. Each month I hope to be able to afford a month in the hospital." In January 1901: "I receive your letter in the hospital where I'm suffering from the eczema on my feet and influenza and also spending the 300 francs that Vollard sends, when he does send them." He came out of

1 **And the Gold of Their Bodies, 1901. Canvas, 26³/₈ × 29⁷/₈ in.
Paris, Musée du Louvre, Jeu de Paume.**

2 **The Witch Doctor of Hiva Oa, 1902. Canvas, 36¹/₄ × 28³/₄ in.
Liège (Belgium), Musée des Beaux-Arts.**

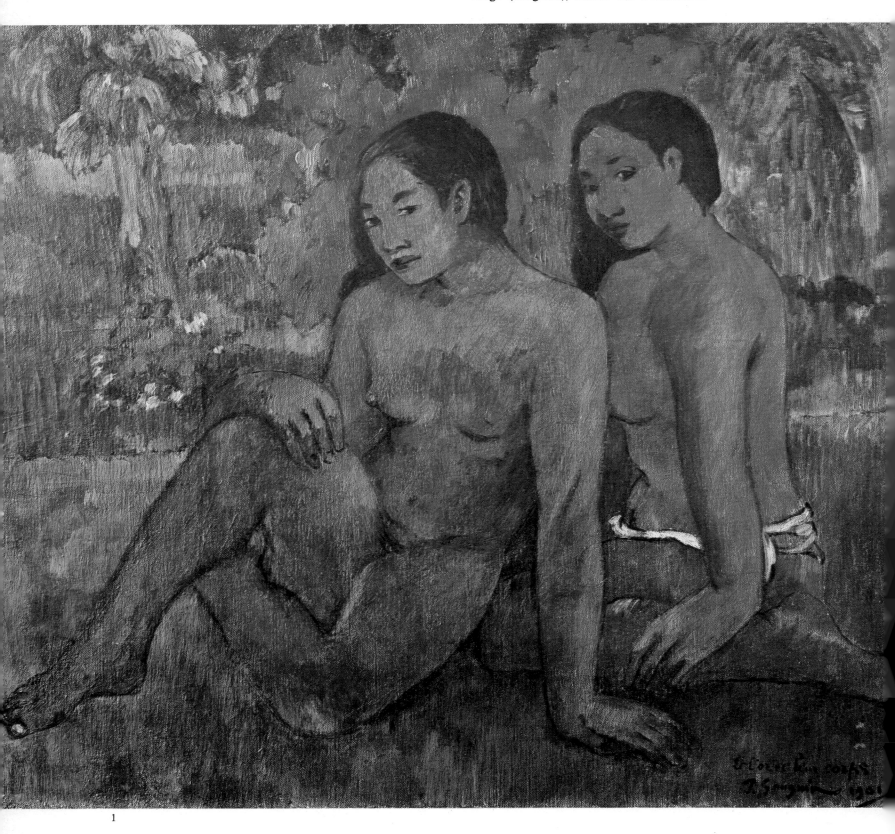

1

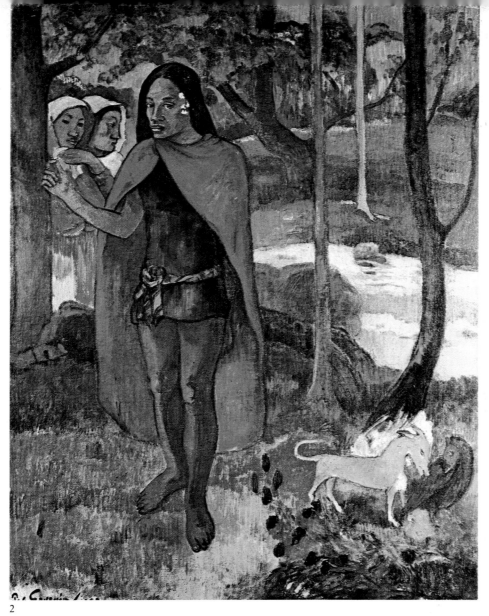

2

the hospital in February. For more than a year he had been too unwell to work, but now, at the request of Gustave Fayet, he began to do some wood carvings.

In April he decided to leave Tahiti for a remoter island in the Marquesas. "In spite of all the love I have for my home, I'm going to try and sell off everything, without too much of a loss. Then I'll go and settle in the Marquesas, where life is very easy and very cheap."

On August 7, 1901, he sold his hut at Punoauia and sailed soon afterward for the Marquesas Islands. On September 16 he landed at Atuana on the island of Hiva Oa; there, in the middle of the village, for 650 francs he bought a strip of land belonging to the local bishop, Monsignor Martin. With the help of native workmen, he built himself a large hut (40 by 18 feet), standing on piles eight feet high, and moved into it at the end of October.

In November he wrote to Daniel de Monfreid: "I am more and more pleased with my choice, and I assure you that from the point of view of painting it is *admirable*. What models!!! A wonder, and I have already

begun to work." His views on painting were by now completely independent of European trends and their fleeting fads and fashions. In the same letter he wrote: "You know what I think of all those false ideas about Symbolist literature or any other as applied to painting. ... In the isolation of a place like this, a man's mind is reinvigorated. Here poetry arises all by itself, and to suggest that poetry you have only to surrender to your dreams as you paint. ... I feel that in art *I am right*, but will I have the strength to give it positive expression? In any case I shall have done my duty, and even if my work does not endure, there will always remain the memory of an artist who freed painting from many of its old academic failings and from Symbolist failings (another brand of sentimentalism)."

Gauguin was thinking deeply and lucidly about himself and others, for he had even achieved a certain serenity despite worsening health and the irregularity of the small remittances that reached him. His art reflected this serener, more thoughtful mood. From the time of his first stay in Tahiti, but more especially

after 1898, it was pervaded by a majestic calm and a deepening sense of man's communion with nature. From its simple grandeur there emanates a certain mystery, a private and intrinsic spirit of religion. This spell of pagan magic and religion becomes more haunting in the Marquesan pictures. In the primitive life of these remote islands Gauguin felt thoroughly at home and entered into deeper sympathy with the natives. As in Tahiti, his resentment was aroused by the new order imposed on old pagan ways by the civil and religious authorities, and he was soon in conflict with them again, defending what seemed to him were the interests of the natives. His first clash was with the bishop, Monsignor Martin, over the instruction given the children in the Christian school. He went out of his way to defy and badger the local officials, creating a fund of ill will that would soon be used against him. In January 1903 the island was devastated by a cyclone. "The water demolished everything in its path. ... I climbed back up to my room and spent an anxious night dreading that the waters would bring down my poor hut. It's a lucky thing I raised it eight feet from the ground and used twice as many braces as required."

His conflicts with people in authority became ever more bitter. He openly urged the natives to throw off the restraints imposed by the church and the colonial administration. His combative attitude won the sympathy of the islanders but earned him the unrelenting hostility of most missionaries and officials. He called his house *La Maison du Jouir*, or "the House of Enjoyment," and carved the name in large letters on the framework above the door. And uninhibited enjoyment of life was the philosophy he preached to

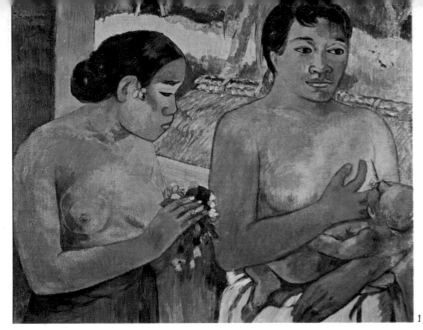

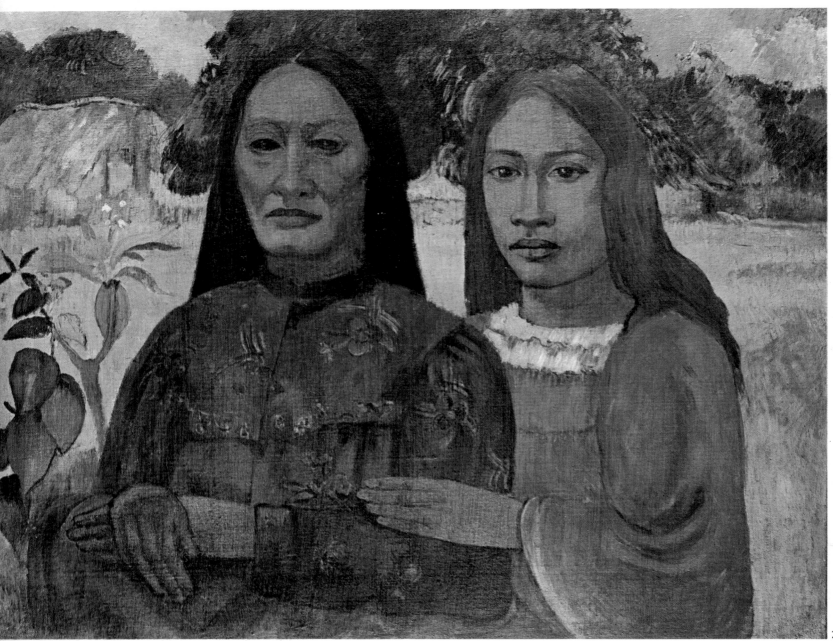

the natives, trying to undermine their respect for established authority and urging them not to pay taxes and to withdraw their children from the mission school. Although he was crippled and could only drag himself about painfully, he made his way down to the beach and persuaded some people from the island of Tuhuata to take their children home. His efforts took effect. As he wrote himself, "The three Catholic schools of Atuana and Puamau numbered more than three hundred pupils four or five years ago, but now they only have seventy." Brooding over the wrongs of the natives, he accused a gendarme of ill-treating one of the islanders. The authorities struck back. In March he was summoned before a visiting magistrate, fined a thousand francs, and sentenced to three months' imprisonment for defamation. But there was no time to enforce the sentence. "He suffered terribly from his legs, which were swollen and

1 The Offering, 1902. Canvas, 26³/₄ × 30⁵/₈ in. Zurich, E.G. Bührle Foundation.
2 Mother and Daughter, 1902. Canvas, 28⁷/₈ × 36¹/₄ in.
Collection of Mr. and Mrs. Walter Annenberg.
3 Two Tahitian women, in a photograph of about 1897 owned by Gauguin.
4 When the Storyteller Speaks. Cylindrical wood carving with four figures,
height 12¹/₂ in. Private collection.
5 Girl with a Fan, 1902. Canvas, 36¹/₄ × 28³/₄ in. Essen, Folkwang Museum.

covered with eczema and abscesses," wrote the Protestant pastor Vernier to Charles Morice. "We talked, to take his mind off the pain, and he spoke to me of his art in admirable terms. ... I did not see him again for ten days. ... I returned to your friend's house and found him very low, lying on his bed groaning. Once again he forgot his pain in speaking of Art. I admired his devotion to it." On May 8, 1903, Vernier wrote: "I found Gauguin lifeless, with one leg hanging out of bed, but still warm. ... Paul Gauguin was dead, and everything indicates that he died of a sudden heart attack."

Even death failed to put an end to

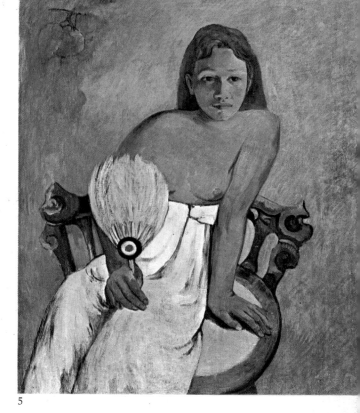

5

the relentless clash between Gauguin and the civilized world. The bishop came at once to the hut, and a number of works he considered indecent are said to have been destroyed. The next day Gauguin was buried in the Catholic cemetery. In July a public sale of his belongings was held in Atuana. In September his remaining works were sold at auction in Papeete. The contents of his hut, including his sketchbooks, were wholly dispersed. The civilized world was quite prepared to forget him, except for a few loyal friends: above all, Daniel de Monfreid, who believed in his genius, and also a young naval officer, Victor Ségalen, who chanced to be in Papeete at the time of the sale and acquired a painting and some drawings and sculptures; also a few collectors who sincerely admired his work and a few dealers, notably Vollard, who made it his business to see that Gauguin, so fatally unrewarded and unrecognized during his lifetime, should become a glorious name after his death.

A large retrospective exhibition, grouping 227 items, was held in Paris at the 1906 Salon d'Automne. It was the final turning point, marking the end of a long tragedy and the beginning of an enduring triumph. Since then, countless exhibitions and books about him have ensured that his life and work will never lapse into oblivion. His faith in his art and his single-minded devotion to it, in the face of great hardships and repeated disappointments, have been justified, and now Gauguin ranks high among the masters of modern art.

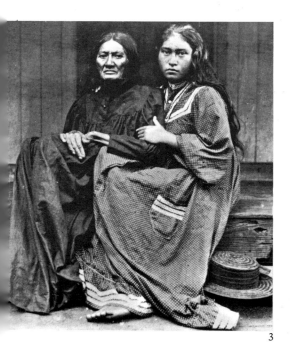

3

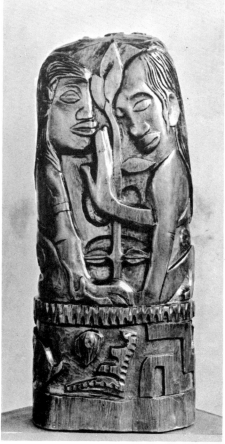

4

DOCUMENTATION

GAUGUIN
YEAR BY YEAR

1874 Clearing in the Woods. Canvas, 19³/₄ × 24 in. Private collection.

Gauguin was a frequent Sunday visitor at the home of his guardian Gustave Arosa in St-Cloud, a countrified suburb of Paris. There, accompanied by his young Danish wife Mette, he painted landscapes in the neighborhood. Though he was still an unskilled beginner, these early canvases show a sensitive feeling for nature.

1875 The Cail Works and the Quai de Grenelle. Canvas. Private coll.

Though married and a busy stockbroker, he went on painting. More proficient now, he painted some views of Paris in a style akin to that of the Impressionists, whose first group exhibition a few months before (April–May 1874) had so shocked the public and critics.

1876 Still Life with Oysters. Canvas, 20¹/₂ × 36¹/₄ in. Private collection.

By now Gauguin had mastered the techniques of painting, and his still lifes reveal another side of his personality. He shows a sure sense of pictorial design in his arrangement of forms; here, more than in his landscapes, a certain classicism inherent in his artistic temperament makes itself felt.

1877 His only dated painting of this year is the "Portrait of Claude-Antoine-Charles Favre," which seems to have little in common with other known works of this early period.

1878 No picture dated by Gauguin himself is known for this year. A "Portrait of Mette" (page 14) is generally attributed to 1878, but only on authority of Pola Gauguin, the artist's son, who was not born until 1883.

1879 Garden under Snow. Canvas, 16 × 19 in. Copenhagen, Ny Carlsberg Glyptotek.

Gauguin had become a thoroughgoing Impressionist and took part in the last five group exhibitions, from 1879 to 1886. Having mastered Impressionist technique under Pissarro's instruction, he recorded his visual impressions of nature with appealing spontaneity.

1880 Flowers on a Chair. Canvas, 21⁵⁄₈ × 25¹⁄₂ in. Winterthur (Switzerland), Collection of Frau Jäggli-Corti.

The innovations in his art brought about by the new technique are even more noticeable in his still lifes, especially when compared with those done in the mid-seventies. Now he adopts a simpler, apparently casual layout, while achieving a subtler rendering of atmosphere and light and preserving the natural character of the objects.

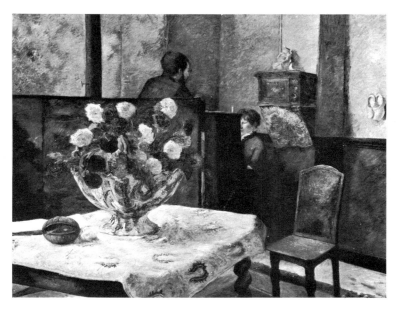

1881 A Room in the Artist's House in Rue Carcel, Paris. Canvas, 51 × 63³⁄₄ in. Oslo, Nasjonalgalleriet.

In his early interiors Gauguin was not quite at ease, as if cramped by limited space and a condensed light, less diffuse than that outdoors. He had not yet overcome this constraint, which also marks the figures.

1882 The Artist's Family in the Garden of Rue Carcel, Paris. Canvas, 34¹⁄₄ × 44⁷⁄₈ in. Copenhagen, Ny Carlsberg Glyptotek.

Gauguin records a quiet moment of family life in the garden of his house in Rue Carcel, near the Vaugirard church. This comfortable middle-class existence, whose serenity obviously had its charms for him, was soon to come to an end when he gave up his stockbroker's job to begin his adventurous career as a painter.

1883 Sloping Road at Osny. Canvas, 30 × 39³/₄ in.
Copenhagen, Ny Carlsberg Glyptotek.

Breaking with the past, Gauguin abruptly left the stock exchange and became
a full-time painter. He went out landscape painting with Pissarro in the Oise
Valley, chiefly at Pontoise and Osny, about twenty miles northwest of Paris.
The sobriety of these pictures perhaps reflects his mood at the time.

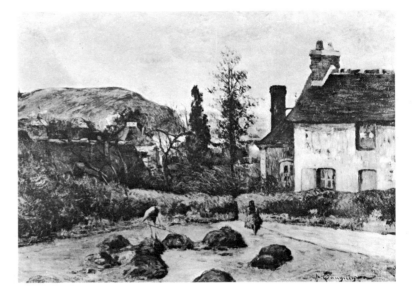

1884 Haymaking. Canvas, 23¹/₂ × 28³/₄ in.
Tokyo, Bridgestone Museum of Art.

Moving to Rouen on the lower Seine, Gauguin worked in a style showing the
influence of the Norman landscape, with its rich vegetation, ever-changing
skies, and lush greenery in which houses are shrouded. Even here in the
presence of nature's abounding vitality, he felt a need to impose a certain
artistic order on what he saw around him.

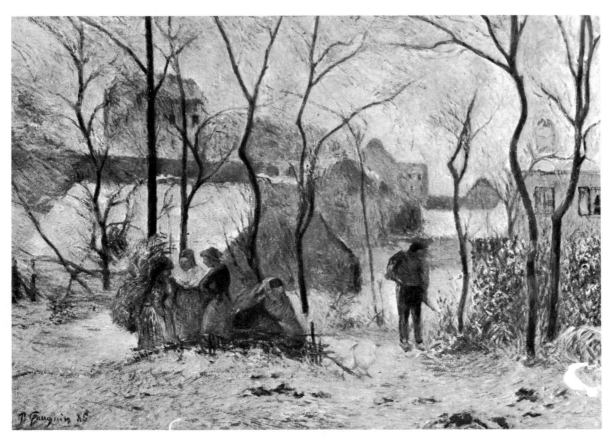

1885 Garden in the Snow.
Canvas, 28³/₄ × 39³/₈ in.
Oslo, Private collection.

This garden and group of buildings
figured in two pictures of 1879 ("Gar-
den under Snow," page 75). Here he
varied the same motif by adding some
figures already used in a picture of
1883. This knack of re-using ele-
ments from previous paintings and
recombining them in the most natural
and effective way is characteristic of
Gauguin, both then and later in Brit-
tany and Tahiti.

1886 Four Breton Women. Canvas, 28¼ × 35¾ in.
Munich, Bayerische Staatsgemäldesammlungen.

Painted in Brittany, this outdoor figure composition shows that, while taking inspiration from nature, Gauguin was not content to copy what he saw before him but arrived at a certain formal patterning which gives the picture subtle decorative appeal.

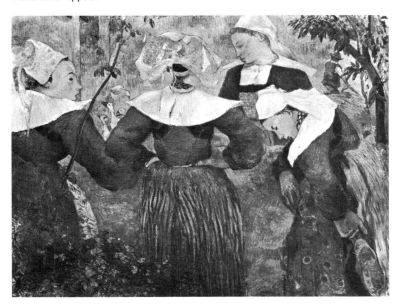

1887 Mango Pickers (Martinique). Canvas, 35¼ × 45¼ in.
Amsterdam, Vincent van Gogh Foundation.

In the landscapes and figure compositions he brought back from Martinique, Gauguin can be seen moving away from Impressionism, particularly in his use of a sharp linear design and, very often, distinct contour lines around forms.

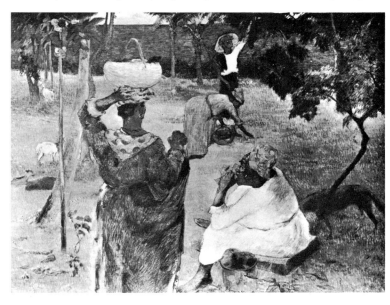

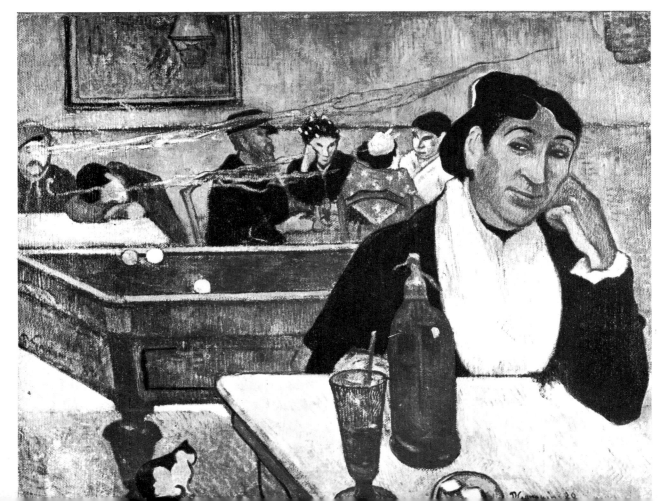

1888 The Night Café, Arles (Madame Ginoux). Canvas, 28¾ × 36¼ in. Moscow, Pushkin Museum.

This was a decisive year in Gauguin's progressive movement from his early Impressionism to a distinctive style of his own. Already in some of his Brittany paintings he had opted for sharply outlined forms and broad areas of uniform color. This new style was more systematically worked out in the last months of 1888 during his stay in Arles. This "Night Café" and its proprietress Madame Ginoux were also painted by Van Gogh.

1889 Self-Portrait as Christ in the Garden of Olives. Canvas,
28³/₄ × 36¹/₄ in.
West Palm Beach (Florida), Norton Gallery and School of Art.

Gauguin was now in full possession of his technical resources and rapidly developing his new style of flattened forms with strong contours and areas of pure color. However systematically applied, his personal style left ample scope for expression of the artist's emotions.

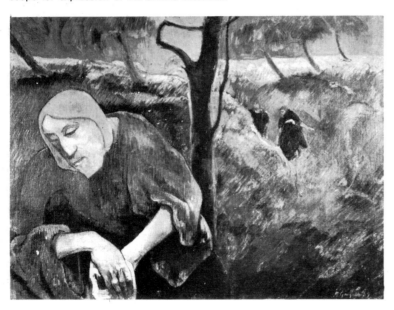

1890 Harvest by the Sea. Canvas, 28³/₄ × 36¹/₄ in.
London, M. Maresco Pearce.

The application of this flat patterning to landscape marks his complete and final break with Impressionism. The rhythm of the picture is no longer created by the flickering play of light or leafage but by broad, interlocking zones of color.

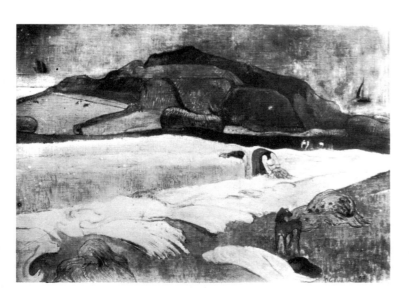

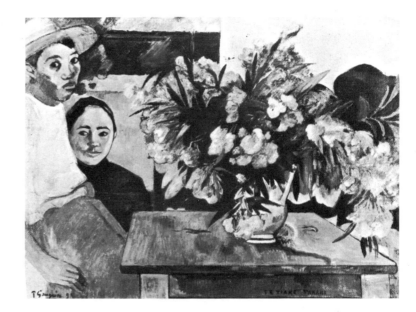

1891 Flowers of France ("Te Tiare Farani"). Canvas, 28¹/₄ × 36¹/₄ in.
Leningrad, Hermitage Museum.

In Tahiti Gauguin felt at once as if he had come home. There all the new ideas he had been developing in his art for years past found expression with a freedom and truthfulness surpassing anything he had achieved before.

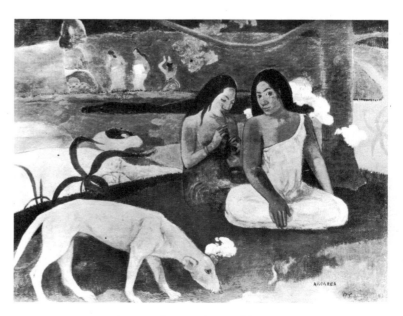

1892 Joyousness ("Arearea"). Canvas, 29¹/₂ × 37 in.
Paris, Musée du Louvre, Jeu de Paume.

Even more than his Martinique canvases, the pictures of daily life in Tahiti rise above the level of a merely picturesque or anecdotal interest. In their serenity and sobriety these figure compositions achieve a new classicism.

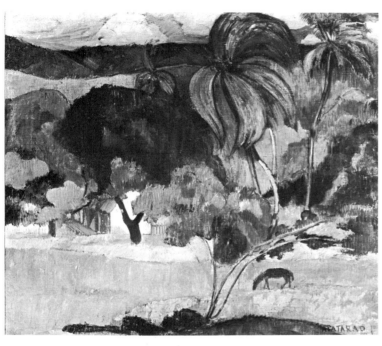

1893 The Apatarao District of Papeete. Canvas, 19¹/₄ × 21¹/₄ in. Copenhagen, Ny Carlsberg Glyptotek.

The Tahitian landscapes, to an even greater degree than those done in Brittany, are reduced to essential patterns. The shapes of terrain and trees have a breadth and elegance that justify their drastic simplification in the interest of style and design.

1894 Two Breton Women on a Road. Canvas, 26 × 36¹/₄ in. Private collection.

Gauguin was back in France for a few months and working again in Brittany. Here, too, he shows his power of translating reality into boldly simplified patterns that give style to what might otherwise seem commonplace.

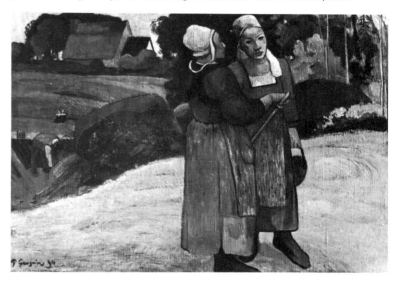

1895 No dated picture is known for 1895, the year of his last stay in Brittany and his final return to Tahiti.

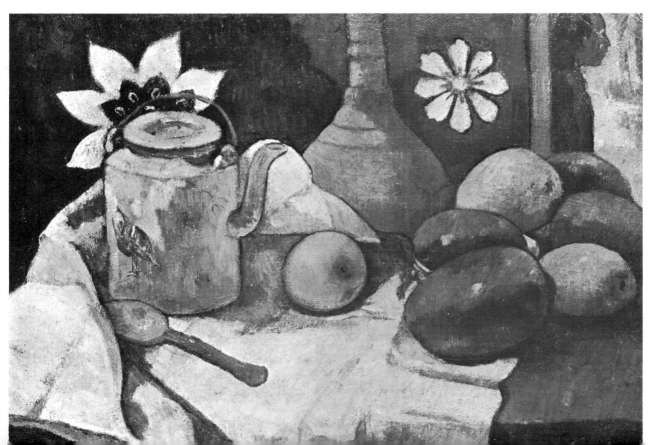

1896 Teapot and Fruit. Canvas, 18⁷/₈ × 26 in. Coll. of Mr. and Mrs. Walter Annenberg.

The Tahiti still lifes are exceptionally fine. They convey the plenitude and breadth of his large-scale compositions; the highly tactile forms of fruit and objects are treated like monumental architecture.

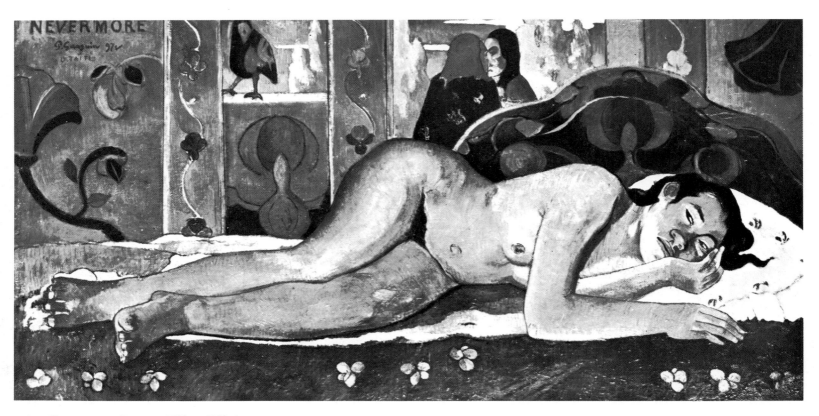

1897 Nevermore. Canvas, 23$^{1}/_{2}$ × 45$^{5}/_{8}$ in.
·London, Courtauld Institute Galleries.

During his second stay in the South Seas, Gauguin gained deeper insight into
the mind of the islanders and extensive knowledge of their religion and lore.
They provided inspiration for some compositions which are at once works of
art and allegories, often pervaded by a sense of anguish that is in fact an
intimation of religious awe.

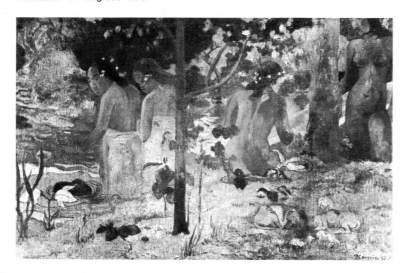

1898 Bathers. Canvas, 23$^{1}/_{2}$ × 36$^{1}/_{4}$ in. Washington, D.C.,
The National Gallery of Art, Gift of Sam A. Lewisohn.

In the compositions of these later years, one feels that Gauguin has found at
last in the native life and natural setting of Tahiti an image of earthly paradise.
Within the natural, elegiac simplicity of this scene, there is an undercurrent
of mystery, an allusion to Oceanic legend.

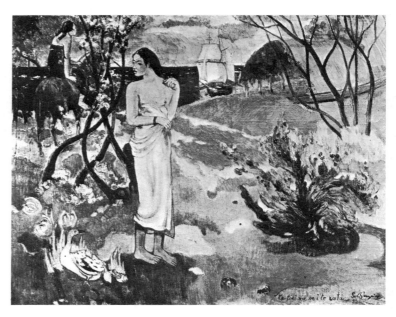

1899 Are You Expecting a Letter? ("Te Tiai Na Oe Ite Rata").
Canvas, 28$^{3}/_{4}$ × 37 in. Private collection.

Perhaps there is a hint of nostalgia, some vague longing for the past in this
picture, for Gauguin was continually expecting letters from France, which
arrived all too rarely. The boat in the background with all sails set is a
further allusion to travel and remembered faraway places.

1900 No painting is known to date from this year.

1901 Near the Huts. Canvas, $25^1/_2 \times 29^7/_8$ in.
Pittsburgh, Museum of Art, Carnegie Institute.

In this year Gauguin left Tahiti for the island of Hiva Oa in the Marquesas, where his style grew freer and mellower. His familiarity with the lush island landscape enabled him to savor its harmonies more fully, to see it now with a certain tenderness and represent it with less rigid stylization.

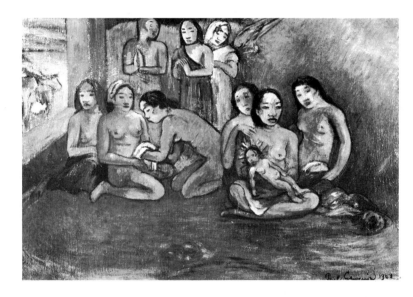

1902 Nativity. Canvas, $17^1/_4 \times 24^3/_4$ in. USA, Private collection.

Undertones of mystery linger on, more tender and human than ever, emanating not from nature but from the figures themselves, whose gestures in nearly all the pictures of this final period have the impressive simplicity and significance of a religious observance.

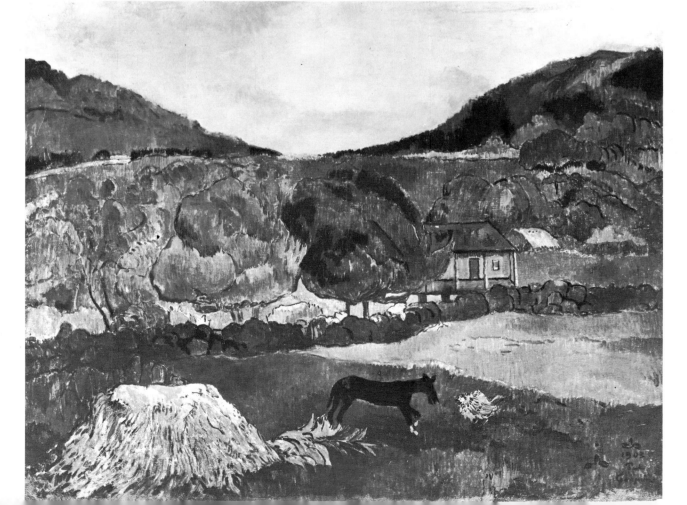

1903 Landscape with a Dog. Canvas, $28^1/_4 \times 35^3/_4$ in. Private collection.

This only known landscape bearing the date 1903 (the year of Gauguin's death) seems to show signs of restlessness and misgivings, and a certain asperity, as if he were girding himself for a final effort to challenge his destiny.

EXPERTISE

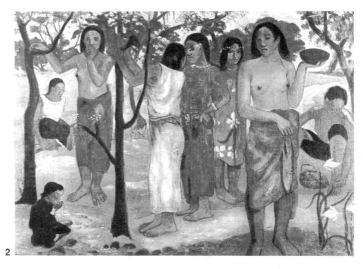

1 The Joy of Rest ("Nave Nave Moe"), 1894.
Canvas, 28³/₄ × 38¹/₂ in. Leningrad, Hermitage Museum.

2 Delightful Day ("Nave Nave Mahana"), 1896.
Canvas, 37 × 51¹/₈ in. Lyons, Musée des Beaux-Arts.

3 Barbaric Tales, 1902. Canvas, 51¹/₈ × 35 in.
Essen, Folkwang Museum.

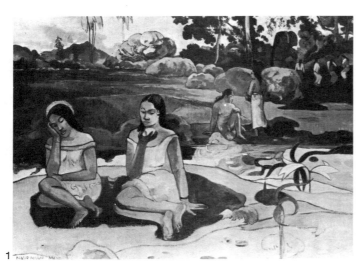

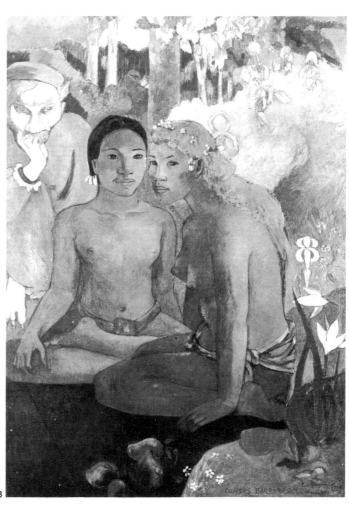

Like all great painters, Gauguin has been a tempting
target for forgers. As in the case of most artists, there
are two general types of fake Gauguins:
1. Pictures by other painters, usually his contemporar-
 ies, which are similar to his in style and handling
 and which have been made to pass for Gauguins
 by adding a signature to them.
2. Pictures deliberately contrived by forgers to look
 like a genuine Gauguin by combining distinctive fea-
 tures of his style. The usual procedure consists in
 extracting elements from several different pictures
 and regrouping them in the semblance of an original.
 For example, the painting apparently exhibited at
 the Houston Museum in 1954 under the title *Nave*

Nave Mahana is made up of figures taken from various pictures ranging in date from 1892 to 1902. Though it is true that Gauguin sometimes used the same figures in different pictures, it is most unlikely he took them from works spanning so long a period of time. Comparison with the originals, moreover, shows up the forger's technical shortcomings. Comparison of technical features remains the most effective way of detecting fakes. The Cézannesque still lifes of 1890, for example, have attracted several forgers. But whereas Gauguin models his forms with a series of broad parallel brushstrokes, the forgers, unable to match his secure sweep of the brush, lapse into irregular, disorderly brushstrokes and the resulting forms are more blurred, both in detail and in overall effect.

4 "Nave Nave Mahana," undated. $27^1/_8 \times 35^3/_8$ in.
Exhibited in Houston in 1954.
This is a fake composed of elements taken from different pictures by Gauguin.

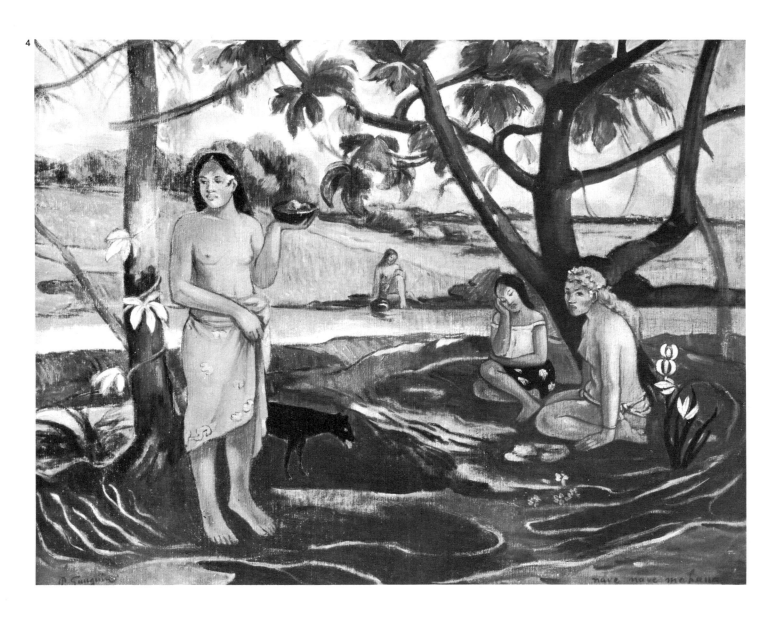

GAUGUIN'S CARICATURES

A sharp and critical observer, Gauguin was inevitably led to indulge in caricature, to point up the ridiculous side of people and situations, and even his own failings. (The drawing opposite, for example, shows him and his children in a bowl of molasses—"dans la mélasse," i.e., in a fix or penniless). Caricatures appear very early in his work, on loose sheets, in letters, and on many pages of his sketchbooks.

2

1 Drawing in a letter to Marie Heegard. Paris, Bibliothèque Nationale.

2 Sketches of Gauguin, his children, house, and maid in Copenhagen, drawn on the letterhead paper of Dillies & Co., the tarpaulin manufacturer which Gauguin represented in Denmark in 1885.

From the STOCKHOLM SKETCHBOOK
1878–1883
Stockholm, Nationalmuseum
(Photo Nationalmuseum)

From the BRITTANY SKETCHBOOK
1884–1888
annotated by
Raymond Cogniat
and John Rewald

1

From the WALTER SKETCHBOOK
c. 1888–1902 (unpublished)
Paris, Musée du Louvre, Cabinet des Dessins

Three drawings done about 1889–1890:

1 Caricatures of Roderic O'Connor (left), Meyer de Haan (top center), and Gauguin (right).

2 Mask of Meyer de Haan(?).

3 Sketch for the main motif of the picture "The Golden Harvest," with a caricatured face substituted for left side of the landscape.

2

3

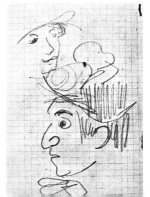

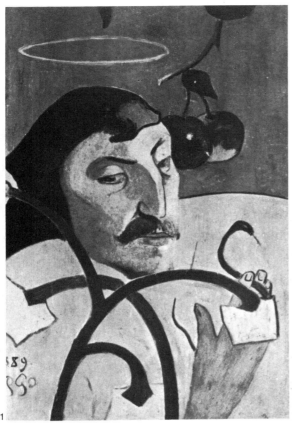

**From the SKETCHBOOK
OF PAUL GAUGUIN**
1888–1890
annotated by René Huyghe
Paris, Musée du Louvre,
Cabinet des Dessins

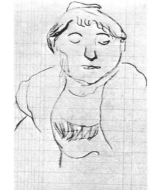

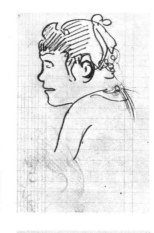

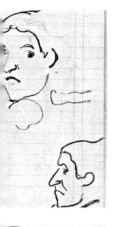

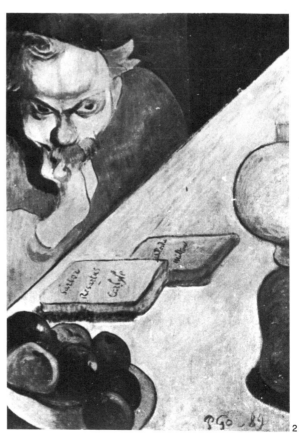

1 The Schuffen-
ecker Family
in the Rue Bou-
lard Studio,
Paris, 1889.
Canvas, 28³/₄
× 36¹/₄ in.
Paris, Musée du
Louvre,
Jeu de Paume.

2 Portrait of
Meyer de Haan
painted on
cupboard door
in inn of
Marie Henry
at Le Pouldu,
1889. Oil on
wood, 31¹/₂ ×
20¹/₂ in. New
York, Private
collection.

3 From Emile
Bernard's
sketchbook:
Louis Roy
and Gauguin.
Paris, Musée du
Louvre, Cabinet
des Dessins.
(Photo Musées
Nationaux)

4 Gauguin
caricatured
as an Indian.
(Paris World's
Fair, 1889)

**From the TAHITI
SKETCHBOOK**
1891–1893
annotated by
Bernard Dorival

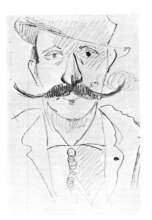

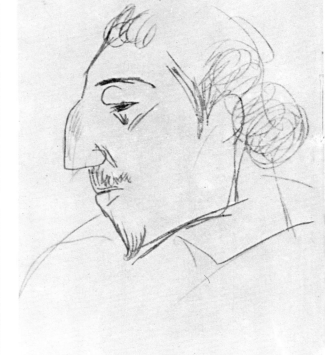

From the ELEVEN MENUS
December 1899–June 1901
For a meal to which apparently eleven
guests were invited, Gauguin wrote
out the menu cards and decorated
them with watercolor sketches on
themes he had already treated in
Brittany and more recently in Tahiti.
They show the gusto with which he
brought his sense of humor to bear
on things and people.

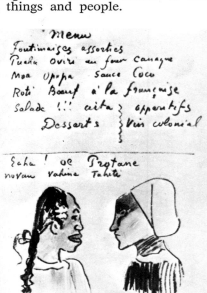
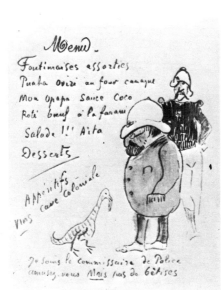
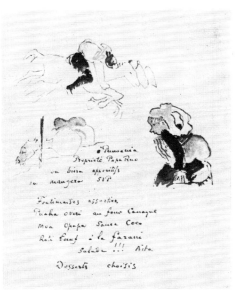

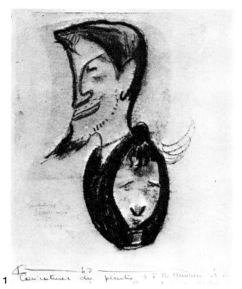

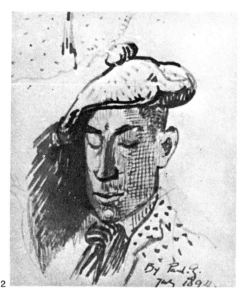

Various caricatures
1890–1897

1 Pont-Aven, c. 1890.

2 Pont-Aven, 1894.

3 Tahiti, c. 1896–1897.

4 Tahiti, c. 1891–1893.

5 Tahiti, c. 1897–1898.

6 Tahiti, c. 1891–1893.

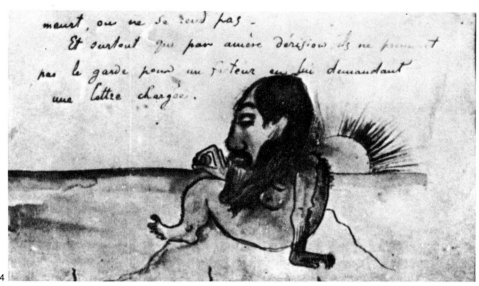

NOA NOA and OTHER SKETCHES
1895–1898

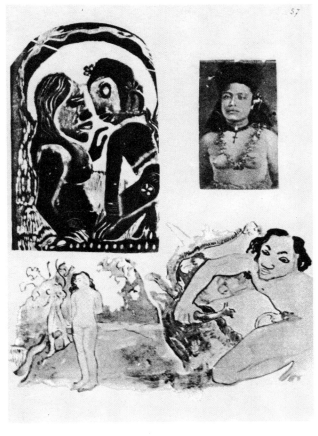

Gauguin did many drawings and watercolor sketches to illustrate manuscripts in which he described the life, customs, and beliefs of the islanders.

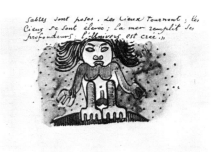

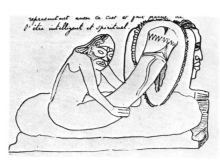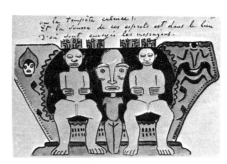

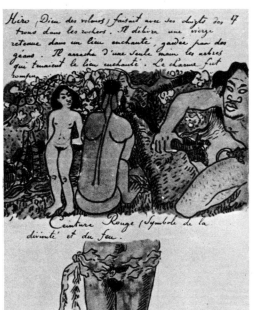

ANCIEN CULTE MAHORIE
(Ancient Maori Worship)
c. 1892

These drawings illustrate and document native beliefs and mythology. Artistically, they are a combination of stylization and caricature, both tendencies being deliberately emphasized by the artist.

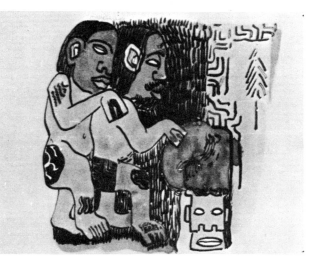

Drawings made on pages of "Les Guêpes" and "Le Sourire," 1899–1901.

Les Guêpes

In his jottings and the sketches with which he illustrated his manuscripts, Gauguin gave free rein to his sense of humor, which became bluntly aggressive in the last months of his stay in Tahiti, in 1901, when his conflicts with the French colonial authorities became especially bitter. From the fact that he often drew on pages from *Les Guêpes* and *Le Sourire*, one might infer that he intended these caricatures to be used as illustrations in these two publications.

From LE SOURIRE
(The Smile)
1899–1900

Journal Sérieux

Journal méchant

After contributing to *Les Guêpes*, a satirical journal published in Papeete, Gauguin launched a paper of his own, *Le Sourire*, written and illustrated entirely by himself, in which he ridiculed his enemies. Its ironic subtitle *Journal Sérieux* ("a serious paper") was soon changed to *Journal Méchant* ("a naughty paper"). It appeared from August 1899 to April 1900. A special number dedicated to a Mr. Cardello is inexplicably dated August 1891.

PROPRIETE Coloniale

— La beauté humaine —

— Vivent de leur beauté

BOOKS ABOUT GAUGUIN

The point of departure for any study of Gauguin is the biography by Jean de Rotonchamp, *Paul Gauguin*, Crès, Paris, 1925.

The artist's own letters are a primary source of information: *Lettres de Gauguin à sa femme et à ses amis*, edited by Maurice Malingue, Grasset, Paris, 1946; enlarged edition, 1949. *Lettres de Gauguin à Daniel de Monfreid*, introduction by Victor Ségalen, edited by A. Joly-Ségalen, Falaize, Paris, 1950. *Lettres de Paul Gauguin à Émile Bernard*, Cailler, Geneva, 1954. In English, see Paul Gauguin, *Letters to Ambroise Vollard and André Fontainas*, edited by John Rewald, San Francisco, 1943.

Gauguin left a number of writings in manuscript which have been published, some in facsimile editions, with commentaries by Gauguin scholars: *Ancien Culte Mahorie* (1892?), commentary by René Huyghe, facsimile edition by Pierre Bérès, La Palme, Paris, 1951; *Cahier pour Aline* (1893?), commentary by Suzanne Damiron, facsimile edition by D. Jacomet, Paris, 1963; *Noa Noa* (1893–94?), manuscript of the first draft published in facsimile by Sagot-Le Garrec, Paris, 1954; another manuscript of *Noa Noa*, edited by Charles Morice and annotated by Jean Loize (A. Balland, Paris, 1966), was published in facsimile by Fritzes Hovhokhoudel, Stockholm, 1947. For Gauguin's contributions to *Les Guêpes* (Papeete, 1899–1901), see *Gauguin journaliste à Tahiti et ses articles des "Guêpes"* by Bengt Danielsson and Patrick O'Reilly, Société des Océanistes, Musée de l'Homme, Paris, 1966. For the nine issues and three supplements of *Le Sourire* (Papeete, 1899–1900), see *Le Sourire de Paul Gauguin*, facsimile edition, introduction and notes by L. J. Bouge, Maisonneuve et Cie, Paris, 1952. *Onze Menus de Paul Gauguin* (December 1899–June 1901), commentary by Robert Rey, G. Cramer, Geneva, 1950; *Racontars d'un Rapin* (1902?), edited by A. Joly-Ségalen, Falaize, Paris, 1951; *Avant et Après* (1903?), facsimile edition by Kurt Wolff, Leipzig, 1918, regular edition edited by Jean Loize, A. Balland Editeur & Spadem, Paris, 1966. In English, see *Paul Gauguin, Intimate Journals*, translated by Van Wyck Brooks, Indiana University Press, Bloomington, 1958 (transl. of *Avant et Après*); *Paul Gauguin, Noa Noa, A Journal of the South Seas*, translated by O. F. Theis, Noonday Press, New York, 1957; *Paul Gauguin, Noa Noa, Voyage to Tahiti*, translated by Jonathan Griffin, Oxford, 1961, and New York, 1962.

Several of Gauguin's sketchbooks (*carnets*) have been published in facsimile editions, with comments and notes by specialists. There are six such sketchbooks: the Stockholm Sketchbook, *Carnet de Stockholm* (c. 1878–1883, unpublished), in the Nationalmuseum, Stockholm; the Brittany Sketchbook, *Carnet de Bretagne* (c. 1884–1888), published as *Paul Gauguin, A Sketchbook*, with text by Raymond Cogniat and foreword by John Rewald, Hammer Galleries, New York, 1962; the

Briant Album (c. 1887–1888, unpublished), in the Musée du Louvre, Paris; the *Carnet de Paul Gauguin* (c. 1888–1890), facsimile edition with commentary by René Huyghe, Quatre Chemins-Editart, Paris, 1952; the *Carnet de Tahiti* (c. 1891–1893), a sketchbook from Gauguin's first voyage to Tahiti, facsimile edition with commentary by Bernard Dorival, Quatre Chemins-Editart, Paris, 1954; and the Walter Sketchbook, *Carnet Walter* (c. 1888–1902, unpublished), in the Musée du Louvre, Paris. Among the most important biographies and studies of Gauguin are the following: A. Alexandre, *Paul Gauguin, Sa vie et le sens de son oeuvre*, Bernheim-Jeune, Paris, 1920; Georges Boudaille, *Gauguin*, Thames and Hudson, London, 1964; F. Cachin, *Gauguin*, Le Livre de Poche, Paris, 1968; Charles Chassé, *Gauguin et le groupe de Pont-Aven*, Paris, 1921; *Gauguin et son temps*, Bibliothèque des Arts, Paris, 1955; *Gauguin sans légendes*, Editions du Temps, Paris, 1965; Bengt Danielsson, *Gauguin in the South Seas*, New York–London, 1965; Charles Estienne, *Gauguin*, Skira, Geneva–London–New York, 1953; Pola Gauguin, *My Father Paul Gauguin*, London–New York, 1937; Robert Goldwater, *Gauguin*, Abrams, New York, and Thames and Hudson, London, 1957; Wladyslawa Jaworska, *Paul Gauguin et l'École de Pont-Aven*, Ides et Calendes, Neuchâtel (Switzerland), 1971 (transl., *Paul Gauguin and the School of Pont-Aven*, Thames and Hudson, London, 1972); Maurice Malingue, *Gauguin*, Documents d'Art, Monaco–Paris, 1943; M. Malingue, *Gauguin, Le peintre et son oeuvre*, Presses de la Cité, Paris, 1948; Kuno Mittelstädt, *Gauguin: Self-Portraits*, Faber & Faber, London, 1968; Henri Perruchot, *Gauguin*, Paris, 1961, and Cleveland, 1964; John Rewald, *Gauguin*, Hyperion, New York, 1938; J. Rewald, *Gauguin*, Abrams, New York, 1969. See also John Rewald, *Post-Impressionism, From Van Gogh to Gauguin*, Museum of Modern Art, New York, 1956.

Catalogue of the paintings: Georges Wildenstein, *Gauguin*, Vol. I, Catalogue, Les Beaux-Arts, Paris, 1964.

Catalogue of the lithographs, woodcuts, and etchings: Maurice Guérin, *L'oeuvre gravé de Gauguin*, 2 vols., Floury, Paris, 1927.

For the sculpture and ceramics: Merete Bodelsen, *Gauguin's Ceramics, A Study in the Development of His Art*, Faber & Faber, London, 1964; Christopher Gray, *Sculpture and Ceramics of Paul Gauguin*, Johns Hopkins Press, Baltimore, 1963.

For the drawings: R. Pickvance, *The Drawings of Gauguin*, Hamlyn, London, 1970; John Rewald, *Gauguin Drawings*, Yoseloff, New York, 1958.

● **MUSEUMS WITH AT LEAST 3 WORKS BY GAUGUIN**

● **MUSEUMS WITH LESS THAN 3 WORKS BY GAUGUIN**

GAUGUIN IN MUSEUMS

Museums with at least 3 works by Gauguin

EUROPE

BASEL – Kunstmuseum
BRUSSELS – Musées Royaux des Beaux-Arts de Belgique
COLOGNE – Wallraf-Richartz Museum
COPENHAGEN – The Royal Museum of Fine Arts; Ny Carlsberg Glyptotek; Ordrupgaardsamlingen
EDINBURGH – National Gallery of Scotland
ESSEN – Folkwang Museum
GÖTEBORG – Konstmuseum
LENINGRAD – Hermitage Museum
LONDON – Tate Gallery
MOSCOW – Museum of Modern Western Art; Pushkin Museum
MUNICH – Bayerische Staatsgemälde-sammlungen
OSLO – Nasjonalgalleriet
PARIS – Musée du Louvre (Jeu de Paume)
STOCKHOLM – Nationalmuseum

NORTH & SOUTH AMERICA

BOSTON – Museum of Fine Arts
CHICAGO – The Art Institute of Chicago
NEW YORK – The Metropolitan Museum of Art; The Museum of Modern Art
SAN ANTONIO – Marion Koogler McNay Art Institute Museum
SÃO PAULO – Museu de Arte
WASHINGTON, D.C. – The National Gallery of Art

ASIA & OCEANIA

PAPEARI (Papeete) – Gauguin Museum
TOKYO – Bridgestone Museum of Art; Ishibashi Foundation